Visual
Knowing

For my sons

Visual Knowing

Connecting Art and Ideas Across the Curriculum

DONOVAN R. WALLING

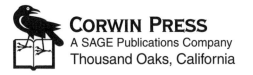
CORWIN PRESS
A SAGE Publications Company
Thousand Oaks, California

For information:

Corwin Press
A Sage Publications Company
2455 Teller Road
Thousand Oaks, California 91320
E-mail: order@corwinpress.com

Sage Publications Ltd.
1 Oliver's Yard
55 City Road
London, EC1Y 1SP
United Kingdom

Sage Publications India Pvt. Ltd.
B-42 Panchsheel Enclave
Post Box 4109
New Delhi 110 017 India

Printed in the United States of America

Library of Congress Cataloging-in-Publication Data

Walling, Donovan R., 1948-
Visual knowing: connecting art and ideas across the curriculum / Donovan R. Walling.
　　　p. cm.
Includes bibliographical references and index.
ISBN 1-4129-1448-5 (cloth) — ISBN 1-4129-1449-3 (pbk.)
　　1. Arts—Study and teaching—United States. 2. Humanities—Study and teaching—United States. I. Title.
LB1591.5.U57W35 2005
700'.7'073—dc22

　　　　　　　　　　　　　　　　　　　2004027695

This book is printed on acid-free paper.

05　06　07　08　09　10　9　8　7　6　5　4　3　2　1

Acquisitions Editor:	Faye Zucker
Editorial Assistant:	Gem Rabanera
Production Editor:	Tracy Alpern
Copy Editor:	Cate Huisman
Proofreader:	Richard Moore
Typesetter:	C&M Digitals (P) Ltd.
Cover Designer:	Michael Dubowe
Graphic Designer:	Anthony Paular

Contents

Acknowledgments

Corwin Press extends its thanks to Pamela Fannin Wilkinson, educational consultant, Houston, Texas, and to Virginia Usnick, University of Nevada, Las Vegas, for their contributions to this book.

About the Author

Donovan R. Walling is nationally recognized in the field of art education. He is the author of *Rethinking How Art Is Taught: A Critical Convergence* (Corwin Press, 2000), a book-length chapter on visual and performing arts for the Association for Supervision and Curriculum Development's *Curriculum Handbook* (2002), and the "Art in the Schools" article for Macmillan's *Encyclopedia of Education* (2003). He also is author or editor of 11 professional books for educators, as well as numerous articles and other publications. His most recent anthology is *Public Education, Democracy, and the Common Good* (Phi Delta Kappa Educational Foundation, 2004).

He has taught art, English, and journalism in the United States and abroad. He served as a curriculum administrator in public school districts in Wisconsin and Indiana prior to his current position as director of publications and research at Phi Delta Kappa International, the professional association in education. He lives in Bloomington, Indiana.

Introduction:
Art and . . .

A rt dwells at the core of human endeavor. Since the first humans picked up tools, there has been art—beginning with images sculpted, incised, or painted. We may not know for certain the purposes of the Paleolithic bulls and bison painted in the caves at Altamira, Spain, or Lascaux, France. But we do know that these artworks, dating from 15,000 to 10,000 years B.C., were somehow connected to the lives of these ancient people. They likely were more than mere representations. Many authorities believe that the images were regarded as magical, painted to ensure a successful hunt, for example.

Through the centuries, such connections between art and ideas have been ever present. The purpose of this book is to explore connections between the visual arts specifically and "ideas" that cut across the school curriculum. If "art and . . ." were a question, the answer would be "everything."

Some art, as we suppose was the case in the prehistoric cave paintings, serves ritualistic purposes, from ancient magic and later religious symbolism to modern counterculture iconography. Two- and three-dimensional images, in other cases, represent or describe reality, fantasy, and all points in between, from the mundane to the sublime. Art provides the currency of ideas.

Busy educators may well ask, Why should I take the time to structure lessons that connect art and ideas? How will so doing make my students better at math or reading or writing? One answer is that the visual arts offer an alternative cognitive conduit for learning. Most classroom content is understood by students through reading and listening, rather than seeing and doing. Teachers of all subjects—especially those who have noticed

that the visual learners in their classes are struggling, which often can be the case in academic classes—will find that this manner of approaching subject matter offers a pathway to understanding content that is effective for students with various learning styles. As arts education scholar Elliot Eisner at Stanford University puts it: "One cognitive function the arts perform is to help us learn to notice the world."[1]

Another answer to the harried educator's question is that connecting art and ideas makes visible the notion of *transference*—that is, the application of knowledge or information gained in one context to some other context. Most teachers have had the frustrating experience of trying to get students to apply a concept that they have supposedly learned in another class to a project or an assignment in their class. Transference is not automatic. Applying knowledge across contexts is a learned skill. Helping students make connections between art and ideas is one strategy for teaching and reinforcing the skill of transference.

All of this is not to say that art is not important in itself and singularly worthy of study: art *as* idea. We do well to remember Swiss painter Paul Klee's (1879–1910) admonition: "Art does not reproduce what is visible; rather it makes things visible." Art has the unique quality of being simultaneously communicative and significant both in itself and beyond itself. For example, Picasso's famous mural *Guernica* is a compelling painting for its composition—the use of line and texture, shape and volume—its visual artistry, in other words. But it also conveys and connects to "ideas," such as Picasso's outrage at the bombing of the Spanish city of Guernica and thus also to the historical events surrounding the Second World War; and from a perspective of art history, it places Picasso's work in the pantheon of Modern art. Composition, technique, symbolism, history—all are connections between art and ideas.

HOW TO USE THIS BOOK

Ideas are starting points—for thought, discussion, reading, viewing, writing, and making. This book is a collection of starting points designed to help teachers and students connect the visual arts to ideas that ripple across the school curriculum.

Most of these starting points can be used in more than one subject. For example, the ideas in Chapter 10, "Art and Performance," draw on the work of French writer, artist, and filmmaker Jean Cocteau. There are connecting ideas that can be used in instruction related not only to drama (theater, film) but also to a range of subjects, from literature and mythology to religious expression and history. Performance techniques and theater

technology are other connecting points. Another example—Chapter 6, "Art and History"—refers to Margaret Bourke-White's post–World War II photographs, which can be starting points for studying history, war, biography, and portraiture, in addition to photographic technique.

Each idea chapter focuses on a featured artist and includes information about other artists, writers, scientists, and so on. Teachers can use the central idea as a theme around which to build one or a series of lessons. And teachers of various subjects can use the same starting points to structure different learning journeys. The intent of the approach is to stimulate instructional creativity rather than to provide a cookbook of preconceived lessons.

In a very real sense, these idea chapters are intended to be brainstorms on paper rather than in-depth treatments of any artist or subject. They should encourage thought, stirring up related ideas simply from reading the chapters and considering their content. But each chapter goes a bit further with the inclusion of Visual Thinking Questions and Suggested Reading.

The Visual Thinking Questions are framed at the teacher level, with the notion that teachers will translate these general questions into a form that their students, at whatever level, can understand. These questions serve as additional starting points, and teachers can develop related questions to further extend the ideas.

Likewise, the books in each chapter's Suggested Reading section, most published later than 1990 (and therefore, hopefully, widely available), are included for the teacher, primarily for background information prior to teaching. But many of the suggested books also are suitable for students, particularly those in higher grades.

Finally, each chapter includes references to images, such as paintings, etchings, sculptures, and photographs. The images referenced in **bold** on first mention denote that the image is available on the Internet. Although all of these images can be found in books, almost universal access to the Internet may provide them more readily. Each chapter's Online Images section makes accessing the images on the Internet a quick and easy way to provide background or develop lessons based on the chapter ideas. Of course, a drawback is that Internet addresses can be ephemeral. All of the image URLs were current at the time of writing. If readers find a dead link, they should be able to locate the image on a different Web site by using a search engine, such as Google or Dogpile, and entering the title of the work and the artist's name.

A word of caution about the online images: They are intended for reference only. Readers are advised to check for copyright restrictions before downloading or reproducing any of the images.

Finally, as a further aid to lesson planning and instruction, at the end of this book is an Idea Guide with three sections: a Subject Guide relating the various chapters to major school subject areas (such as language arts, mathematics, and social sciences), a Keyword Index to ideas that can be found in the various chapters, and an Artist Name Index to help readers find all of the references to the various artists mentioned in the book. Because the chapters are relatively short, the Idea Guide entries are referenced to chapters, rather than individual pages. All of these handy references will be useful in designing effective and thought-provoking lessons that connect the visual arts to subjects across the curriculum.

Note

1. Eisner, Elliot W. (2002). *The arts and the creation of mind*. New Haven, CT: Yale University Press, p. 10.

1 Art and Biography

Few artists better exemplify the connection between art and biography, or autobiography, than the Dutch artist, Rembrandt van Rijn (1606–1669). Born in Leiden, where he maintained a studio after leaving the University of Leiden to study painting, Rembrandt belongs to the Baroque period of Dutch art. This era emerged around 1600 as a reaction against the formulaic Mannerist style that dominated the Late Renaissance. Rembrandt was influenced by the paintings of Italian artist Michelangelo Caravaggio (c. 1571–1610), particularly in the dramatic use of light and shadow. Other artists of the Baroque period include Italian sculptor Gianlorenzo Bernini (1598–1680), Spanish painter Diego Velázquez (1599–1660), Flemish painter Peter Paul Rubens (1577–1640), and Rembrandt's fellow Dutch painter Jan Vermeer (1632–1675).

Rembrandt is best known for his paintings and etchings in two genres: portraits and scenes of historical events. He became the leading portrait painter of his day in Holland and, in 1631, moved to Amsterdam, where he spent the rest of his life. In the centuries before the invention of photography, many artists made their livelihood by making portraits, usually of wealthy individuals who could afford to pay for such work. Rembrandt extended his fame and fortune by also selling lower-priced etchings, which persons of more modest means could afford. Often the subjects of the etchings were images taken from his paintings. In his time, such etchings were the counterpart of today's posters and postcards that bear the images of famous artworks.

Although Rembrandt painted many individuals' portraits, he was undoubtedly his own favorite model. He often used his own face to study his art. Consequently his many self-portraits form a kind of autobiography.

For example, his 1634 **Self Portrait as a Young Man** shows the artist full of self-confidence at the height of his fame, only three years after his move to Amsterdam. By contrast, the 1660 **Portrait of the Artist at His Easel** shows a careworn Rembrandt nine years before his death, at a time when he was living beyond his means and burdened by massive debt.

Artistic portraits have always served many purposes, from catering to the vanity of their subjects to more lofty aims, such as recording the image of a famous person for posterity. Portraits can range from intimate (some tiny, such as miniatures) to public and even massive, such as **Mount Rushmore,** by sculptor Gutzon Borglum (1867–1941), with its huge heads of presidents Washington, Jefferson, Lincoln, and Theodore Roosevelt. The most successful portrait artists delve beneath the surface, however. They attempt to portray the essential, not merely the superficial, characteristics of the model. The portraitist tells a story. Thus, portraiture is at its best when it provides a visual biography or at least hints at what lies within the individual.

This is true not only in painting but in other media as well. Examples abound in sculpture, for instance, from the regal 1340 B.C. portrait **Bust of Queen Nefertiti**, wife of the controversial pharaoh Akhenaten, to the standing bronze portrait of French novelist Honoré de **Balzac** (completed 1893–1897) by French sculptor Auguste Rodin (1840–1917). Even now—long after the advent of photography—drawn, painted, carved, and cast portraits still provide complex images that convey more than everyday photographs can. It should be noted, however, that the best photo portraitists also make penetrating photographic biographies. The outstanding portrait images created by photographer Richard Avedon (1923–2004) provide a body of work to rival the best in portrait painting and are readily accessible in magazines, such as *The New Yorker*.

Many modern artists have found that less realistic styles of portrayal, such as abstract painting, can be more revealing than painting with camera-like realism. A famous abstract portrait example is the weighty image of the writer and art patron as captured in the 1906 **Portrait of Gertrude Stein** by the quintessential Modernist painter, Pablo Picasso (1881–1973). Many artists in the late nineteenth century and throughout the twentieth century produced abstract portraits, including Rodin (mentioned previously), abstract expressionist Willem de Kooning (1904–1997), and surrealist Salvador Dali (1904–1989).

A popular form of biographical portraiture in schools is created when students draw or make a collage portrait of themselves or their classmates. Mirror, paper, and pencil are all that a student needs for drawing. But many teachers opt for a freer form of expression, one less dependent on drawing skill. That is *collage*. Collage is a form of artwork that combines various materials to compose a unified image. The materials can be almost anything flat, such as scraps of wallpaper, dried flowers, photographs,

clippings from newspapers and magazines, bits of fabric or leather, and feathers. These materials are glued to a flat surface to compose the image. Often, students choose images from magazines or personal photo collections—images to which they particularly relate or that convey something about their thoughts and interests. In this way, the collage becomes truly autobiographical.

Collage did not originate as school art. It was invented by the Cubists in 1906, Cubism itself being the creation of Picasso and Georges Braque (1882–1963). From then to the present day, collage has been used in many art styles. There is even an International Museum of Collage, Assemblage, and Construction in Cuernavaca, Mexico (collagemuseum.com). A worthwhile online gallery site for modern collagists is Collagetown at www.collage town.com.

A collage portrait example is **Tatlin at Home** (1920) by artist Raoul Hausmann (1886–1970). The collage is constructed of pasted papers and gouache, a kind of opaque watercolor. Hausmann's subject is the Russian artist Vladimir Tatlin (1885–1953), the originator of the sculpture movement called *Constructivism*.

Related to collage is *photomontage*, the combining of photographic images in collage fashion. Hausmann, indeed, claimed to have invented photomontage. But the technique has its roots in the mid-nineteenth century with the invention of photography. In fact, making composite photographs was a popular Victorian era amusement. But it was not until the 1920s that photomontage developed as a truly new art form. The center of this development was Berlin, where a group of artists calling themselves *Dada* (a founding member being Hausmann) found a new means of expression that rebelled against the prevailing current of abstraction but did not revert to traditional figurative work.

Finally, there is the humorously biographical portrait technique called *caricature*. Caricaturists exaggerate the features of the model to point out particular characteristics. Often, it is the characteristics that make the model stand out. One of the leading caricaturists was Al Hirschfeld (1903–2003), who worked for the *New York Times* for 70 years and produced some of the most memorable caricatures of famous people over nearly the whole span of the twentieth century. An example is his 1955 **Cleveland Amory Scratching His Head at Typewriter**.

VISUAL THINKING QUESTIONS

1. Artists and writers who have known (or sometimes only known of) one another often have created biographies in different ways. Gertrude Stein wrote a biography of Pablo Picasso, and Picasso painted Stein's

portrait. Rodin sculpted Balzac. What other pairings of artists and writers can be found? What are the characteristics of the resulting visual and literal biographies? What are the commonalities, the differences?

2. Choose a biographical portrait—for example, Hausmann's *Tatlin at Home*—and consider it closely. What characteristics of the model can be identified from the portrait? Can these characteristics be confirmed by reading about the subject of the work?

3. Rembrandt's autobiographical self-portraits trace his life. Choose several of the dated self-portraits and match them to what was happening in Rembrandt's life at each point. Are there other figures whose portraits or self-portraits can be used in this manner? (Consider the portraits of public figures, such as George Washington, Abraham Lincoln, and Mark Twain.)

SUGGESTED READING

Poggi, Christine. (1993). *In defiance of painting: Cubism, futurism, and the invention of collage.* New Haven, CT: Yale University Press.
Schama, Simon. (1999). *Rembrandt's eyes.* New York: Alfred A. Knopf.
Zinsser, William. (1998). *Inventing truth: The art and craft of memoir.* Boston: Mariner Books.

ONLINE IMAGES

Balzac (Rodin)
 www.bc.edu/bc_org/avp/cas/fnart/rodin/balzac1.jpg

Bust of Queen Nefertiti (Egypt, 1340 B.C.)
 pavlov.psyc.queensu.ca/~psyc382/nefertitiside.html

Cleveland Amory Scratching His Head at Typewriter (Hirschfeld)
 www.alhirschfeld.com (search by title)

Mount Rushmore (Borglum)
 www.travelsd.com/parks/rushmore/photos.asp

Portrait of Gertrude Stein (Picasso)
 www.usc.edu/schools/annenberg/asc/projects/comm544/library/images/257bg.jpg

Portrait of the Artist at His Easel (Rembrandt)
 www.ibiblio.org/wm/paint/auth/rembrandt/self/self-1660.jpg

Self Portrait as a Young Man (Rembrandt)
 www.ibiblio.org/wm/paint/auth/rembrandt/self/self-1634.jpg

Tatlin at Home (Hausmann)
 faculty.dwc.edu/wellman/Hausmann.htm

2 Art and the Commonplace

Artistic expression is not elitist. Certainly many artists throughout history have idealized their subjects and concentrated on High Art, painting or sculpting noble subjects and grand designs. But at the same time, a vast number of artists, many unnamed, produced and continue to produce art of the everyday and the mundane. Particularly since the Renaissance, many artists, in fact, have raised the commonplace to High Art. One twentieth-century practitioner who springs to mind is the Pop artist Andy Warhol (1928–1987).

The Pop Art movement began in the 1950s and was the dominant art style of the 1960s. The movement's practitioners emphasized the depiction of objects or scenes from everyday life and employed the techniques of commercial art and popular illustration to do so. Along with Warhol, leading Pop artists include Robert Rauschenberg (b. 1925) and Roy Lichtenstein (1923–1997). Pop artists looked at the consumer culture and treated it as High Art in paintings and sculptures. Warhol's 1962 drawing **Roll of Bills** seems particularly appropriate as an example. The image is simply a roll of currency held with a rubber band.

Warhol became well known for his silk-screened images of everything from ordinary Campbell's soup cans to iconic figures of the day, such as Mao Zedong and Marilyn Monroe. In addition to his works in museums around the world, an extensive collection can be found in the Andy Warhol Museum in his hometown of Pittsburgh, Pennsylvania. The museum can be visited online at www.warhol.org.

Roy Lichtenstein, a Warhol contemporary, abandoned Abstract Expressionism in 1961 to produce Pop images, one of his first being an oil painting titled **Kitchen Stove** (1961–1962). It shows an ordinary kitchen

stove with the oven door open to display various baked goods. The painting's palette is limited to yellow, white, and purple, exemplifying another characteristic of Pop Art, the use of flat, bright colors.

Although Pop Art raised everyday scenes and objects to the level of High Art, the movement was not the first expression of the commonplace to gain acceptance by society's elites. Indeed, the tradition of still life painting stretches back almost to prehistory. Still lifes have always presented everyday objects in ways that allow the viewer to see them with new meaning. At a distance of time, the viewer also can gain insights into past historical periods. For example, during the Roman era it was popular to decorate homes with wall paintings and mosaics. While many of the artworks that still exist show mythological or heroic scenes, a large number are still lifes that show the kinds of objects Roman homes held and the foods Roman families ate.

The depiction of ordinary objects can be used to trace daily life and culture across the centuries. To give another example, in the eighteenth century a leading still life painter was Jean-Baptiste-Siméon Chardin (1699–1779), whose works documented the lives of the Paris bourgeoisie. He used objects of daily life—pipes, pitchers, goblets—rendered with uncanny realism. In fact, he was called the grand magician by his critics for this outstanding ability. An example is his oil painting titled **The Silver Tureen** (c. 1728), which depicts a silver soup tureen next to a freshly killed rabbit and a dead fowl, various types of fruit, and, humorously, a curious cat.

Impressionist painter Paul Cézanne (1839–1906) also was known for his still lifes, many of which include fruits or vegetables from the area around Aix-en-Provence, France, where he lived. **Still Life with Bowl of Cherries** (1885–1887) is a good example. It shows a simple arrangement of a white bowl filled with red cherries, a jug, a drape, a cloth, and a plate of peaches.

A related type of art that focuses on the commonplace is genre painting. Genre painting (sometimes called *petit genre*) usually tells a visual story or anecdote and often shows an interior scene. The setting in a genre painting (or print) almost always is an ordinary home or a business, such as a mill or tavern. Chardin also was known for his genre paintings, such as **The Return from Market** (1739), which depicts a burdened housewife who clearly has just returned from a tiring shopping trip.

The focus on everyday life in genre painting is not exclusive to the West any more than it is limited to its heyday in seventeenth- and eighteenth-century France. In Japan, for example, Katsushika Hokusai (1760–1849), a painter and wood engraver born in Edo (now Tokyo), is considered one of the outstanding artists of the Ukiyo-e, or "pictures of the floating world" (everyday life), school of printmaking. **Measuring a Pine Tree at Mishima**

Pass in Ko Province, for example, shows a ring of men or boys measuring a large tree by ringing it with their arms. The print is Number 16 from Hokusai's famous series, *36 Views of Mt. Fuji*.

Genre painting is, over the course of time and in practical terms, a sub-category of a broader type: narrative painting. Storytelling depictions of everyday activities can range from play and sporting events to daily work. For example, American painters Thomas Eakins (1844–1916) and Winslow Homer (1836–1910) created scenes of boys sailing, rowing, and running. Illustrator Norman Rockwell (1894–1978) popularized a form of genre painting by crafting everyday, often humorous scenes as illustrations for stories or advertisements in magazines, such as the *Saturday Evening Post* and *McCall's*. His images include restaurants, schoolrooms, barbershops— every imaginable domestic or commonplace setting. An example is **Surprise**, painted for the cover of the *Saturday Evening Post* in 1956. It depicts Rockwell's favorite eighth-grade teacher being greeted by her class on her birthday.

One can carry the theme of art and the commonplace in many directions. Almost all have something to do, at a historical distance, with how we come to understand ordinary life in past times and cultures. This entry point into history does not come only from *objets d'art* (a French term refer-ring to objects of artistic merit), but also from objects of daily use, from mirrors, combs, chairs, pots, pans, and other household objects to trade tools and agricultural implements. Every historical museum holds com-mon objects: the oldest found by archeologists, the newest taken straight from store shelves. All of these objects point to aspects of the cultures that made them, held them, and used them.

What then raises a common craft item, such as a chair, to the status of art? One answer is originality of design. Even the most common chair begins as a design, a one-of-a-kind. Combine this quality with the fame of its designer, and the chair commands notice. An example is **Chaise Longue** (1928), a chrome, steel, and leather creation by Swiss architect Charles-Edouard Jeanneret (known as Le Corbusier, 1887–1965).

Another answer is juxtaposition or manipulation. French-American Marcel Duchamp (1887–1968) found places for himself in both Dada and Surrealism as a conceptual artist. Conceptual art is more concerned with conveying an idea than making traditional paintings or sculptures. When Duchamp mounted a bicycle wheel onto the seat of a common kitchen stool for his 1913 construction, **Bicycle Wheel,** both ordinary objects took on new life as sculpture.

The same is true when American Pop Art sculptor Claes Oldenburg (b. 1929), a Warhol contemporary, placed a gigantic typewriter eraser in the sculpture garden of the National Gallery of Art in Washington, DC.

Today, Oldenburg's everyday object is an anachronism, of course, a piece of history. In the age of computers, how many students have ever used a typewriter, much less a typewriter eraser?

VISUAL THINKING QUESTIONS

1. Artistic beauty can be found in everyday objects, whether they date from ages past or are part of daily life today. They embody culture, place, and history. Other common things serve similar functions in other fields of study. For example, a diary, such as one written by Samuel Pepys or Anne Frank, can attain the status of literature. What are other ordinary things that take on added meaning when studied with an eye to history, literature, art, or culture?

2. Pop artists, such as Warhol, Lichtenstein, and Oldenburg, used oversize scale as a way to draw attention to commonplace objects and images. Other artists have used the opposite, making miniatures that force the viewer to look closely. Consider doll houses, for example, or miniature portrait paintings. In what other ways has scale—making something very big or very small—been used to change how some ordinary thing is regarded?

3. Tracing the history and development of modern technology can foster understanding not only of the roots of that technology but also of the direction it might take in the future. Choose an everyday machine, such as a dishwasher, a hairdryer, or a lawnmower, and trace its development. For instance, what did the lawnmower look like 20, 50, or 100 years ago? What were the key design features? How did it work? Then speculate on what the lawnmower will look like and how it will function 20, 50, or 100 years from now.

SUGGESTED READING

Bailey, Colin B. (Ed.). (2003). *The age of Watteau, Chardin, and Fragonard: Masterpieces of French genre painting*. New Haven, CT: Yale University Press.

Rowell, Margit, & Lowry, Glenn D. (2002). *Objects of desire: The modern still life*. New York: Museum of Modern Art.

Watson, Steven. (2003). *Factory made: Warhol and the sixties*. New York: Pantheon.

ONLINE IMAGES

Bicycle Wheel (Duchamp)
www.beatmuseum.org/duchamp/images/bicycle.jpg

Chaise Longue (Le Corbusier)
www.dundee.ac.uk/museum/Chair7.html

Kitchen Stove (Lichtenstein)
www.nga.gov.au/International/Detail.cfm?IRN=115724&ViewID=3

Measuring a Pine Tree at Mishima Pass in Ko Province (Hokusai)
www.csse.monash.edu.au/~jwb/ukiyoe/fuji10.gif

Roll of Bills (Warhol)
moma.org/collection/depts/drawings/blowups/draw_025.html

Still Life with Bowl of Cherries (Cézanne)
www.ibiblio.org/wm/paint/auth/cezanne/sl/cezanne.cherries.jpg

Surprise (Rockwell)
www.normanrockwellvt.com/Big.jpg/surprise.jpg

The Return from Market (Chardin)
www.ibiblio.org/wm/paint/auth/chardin/market.jpg

The Silver Tureen (Chardin)
www.ibiblio.org/wm/paint/auth/chardin/tureen.jpg

3 Art and Competition

We tend not to think of the arts in the way we think of sports as being essentially competitive. But, in fact, they often are. Competition, as any sports enthusiast will attest, is not merely a way to determine winners and losers. Rather, competition is designed to bring out the best in both (or all) competitors. In the arts, some competitions are formal contests, while others evolve from personal rivalries and collaborations, both friendly and otherwise. Henri Matisse (1869–1954) and Pablo Picasso (1881–1973) famously engaged in a lifelong rivalry that was marked not only by competition but also by deep friendship.

The French artist Henri Matisse was 12 years older than the Spanish-born Picasso. Early in the twentieth century their paths crossed many times before they finally met in 1905. That year both painters exhibited separately at a gallery owned by Ambroise Vollard, who also was Paul Cézanne's (1839–1906) dealer. By so doing, each gained greater recognition than he had previously achieved. Matisse and Picasso both took some inspiration from Cézanne's work, and Matisse owned Cézanne's painting, **Three Bathers** (1875–1877), now in the Musée d'Orsay in Paris. Yet it was not until later in the year that the two—Matisse and Picasso—finally met.

Later in 1905 Matisse exhibited several new works at the Salon d'Automne that were brighter than his earlier works and took the Neo-Impressionist approach drawn from the Impressionist Cézanne even further. Two American expatriates saw these paintings and decided to buy one, **Woman with Hat** (1905). The Americans were Leo and Gertrude Stein, a brother and sister then living in Paris. Both were art connoisseurs and collectors; Gertrude at the time was an unpublished writer.

Gertrude, avant-garde and eccentric, more so than Leo, also was a collector of personalities. She drew about her a salon of leading young, experimental artists and writers of the day, including such individuals as Sherwood Anderson, Ernest Hemingway, Georges Braque, and, of course, Matisse and Picasso. The Stein home at 27, rue de Fleurus, came to be hung with paintings by Renoir, Cézanne, Gauguin, Picasso, Matisse, and many others. And the salon would flourish particularly during the years between the World Wars.

Soon after the Steins purchased Matisse's painting, Matisse and his wife were invited to the Steins' Saturday night salon. Shortly after that, the Steins discovered Picasso, whom they also invited to join them. (Leo purchased Picasso's **Acrobat's Family with Monkey**, 1905, which Gertrude at first despised.) Thereafter, paintings by both artists jockeyed for pride of place in the Steins' collection. The painters' rivalry and competition, usually friendly, sometimes fierce, continued until Matisse's death in 1954. A Web site devoted to their rivalry can be found at www.matisse picasso.org.

While the Matisse-Picasso rivalry was pursued largely informally, formal art competitions also are common and have been throughout history. For example, in Renaissance Italy Filippo Brunelleschi (1377–1446) vied with his fellow Florentine Lorenzo Ghiberti (1378–1455) in a design competition for the second bronze door of the Florence cathedral Baptistery (see Chapter 15). Many special commissions, such as buildings and monuments, are awarded on the basis of design competitions.

Another, more recent example is the competition to create a World Trade Center monument. Designed by Minoru Yamasaki (1912–1986) and completed in 1977, the twin-towered, 110-story **World Trade Center** became a symbol of free enterprise and, indeed, a symbol of New York City. It was destroyed by terrorists using commercial airliners on 11 September 2001. The dust had hardly settled following the horrors of 9/11 before a competition was launched—the World Trade Center Site Memorial Competition—administered by the Lower Manhattan Development Corporation. The corporation received ideas from 13,683 registrants and 5,201 memorial submissions from 63 nations. (Information can be found at the competition Web site: wtcsitememorial.org.)

The winning design, created by Israeli architect Michael Arad (b. 1970) and landscape architect Peter Walker (b. 1933), was announced on 14 January 2004. Titled **Reflecting Absence,** the memorial design combines trees, structures, water, and open spaces that speak to the feelings of loss created by the destruction of the monumental World Trade Center building complex. (Arad was named *Esquire* magazine's "Man of the Month" and featured in the May 2004 issue.)

Sometimes, it is not the architects who are in competition, but the builders themselves. Such was the case in an earlier period in New York City, when the competition was fierce in the late 1920s to construct the city's tallest building. Would it be the **Empire State Building** or the **Chrysler Building**? Each building's developer was determined to win, but in the end the title went to the Empire State Building—by an antenna.

Painting and other art forms also are the subject of international, national, and regional competitions. Such competitions are hosted by a variety of associations, societies, and other groups. Announcements can be found in art periodicals or on the Internet. A useful Web site is called Artshow (www.artshow.com), which lists shows and juried exhibitions.

Competition in the arts encourages both innovation and conformity, often at the same time. But even if a jury awards on the basis of tradition or preconception, the competition may provide a showcase for innovation. Artists with new ideas or new visions, may, in a sense, throw down the gauntlet that challenges other artists to think in new ways. For example, when Picasso exhibited **Les Demoiselles d'Avignon** (1907), a view of five nude prostitutes, several of whose faces are inspired by African masks, the eight-foot high canvas was greeted with shock and outrage. But it did not take many years for artists and critics alike to realize that the painting represented a watershed moment in Modernism. Ironically, the painting also can be recognized as a critique of **Le Bonheur de Vivre** (*The Joy of Life*, 1905–1906), an abstract Modernist idyll painted, of course, by Henri Matisse.

VISUAL THINKING QUESTIONS

1. Jack Flan, in his book about Matisse and Picasso (see Suggested Reading), notes that Picasso sometimes bought a painting by Matisse because he did not understand it and wanted to study it. How does competition in other fields—for example, a sports team studying a video of a rival team in action—stimulate self-reflection and analysis? What are some examples?

2. Gertrude Stein's salon became a hothouse for the cultivation of ideas across the arts—fiction, poetry, painting, sculpture, and so on. Consider how schools might develop similar venues for creative development. How would such a group differ from the typical, subject-focused study group?

3. Is there a downside to competition? In the arts? The sciences? Sports? What are the factors that make competition healthy and productive? And what factors make competition counterproductive or even destructive? Think about how one might go about achieving balance between these negative and positive factors.

SUGGESTED READING

Flam, Jack. (2003). *Matisse and Picasso: The story of their rivalry and friendship.* Cambridge, MA: Westview.

Mellow, James R. (2003). *Charmed circle: Gertrude Stein and company.* New York: Henry Holt/Owl Books. (Original work published 1974)

Tauranac, John. (1995). *Empire State Building: The making of a landmark.* New York: St. Martin's.

ONLINE IMAGES

Acrobat's Family with Monkey (Picasso)
philo.ucdavis.edu/zope/home/cmc/SPA141/PICASSO/acrobats2.html

Chrysler Building (Van Alen)
www.GreatBuildings.com/cgi-bin/gbi.cgi/Chrysler_Building.html/cid_2159832.gbi

Empire State Building (Shreve, Lamb, & Harmon)
www.GreatBuildings.com/cgi-bin/gbi.cgi/Empire_State_Building.html/cid_2164990.gbi

Le Bonheur de Vivre (Matisse)
www.abm-enterprises.net/bonheur.htm

Les Demoiselles d'Avignon (Picasso)
www.pbs.org/wgbh/cultureshock/flashpoints/visualarts/picasso_big.html

Reflecting Absence (Arad & Walker)
wtcsitememorial.org/fin7.html

Three Bathers (Cézanne)
www.abcgallery.com/C/cezanne/cezanne73.html

Woman with Hat (Matisse)
www.matisse-picasso.com/artists/matimages.html

World Trade Center (Yamasaki)
www.GreatBuildings.com/cgi-bin/gbi.cgi/World_Trade_Center.html/cid_wtc_mya_WTC_finished2.gbi

4 Art and Conflict

Conflict—good versus evil, war and its consequences—is the stuff of drama, whether on stage, paper, or canvas. A dramatic starting point for this chapter is the large oil painting by Spanish artist Pablo Picasso (1881–1973) called **Guernica**. The northern Basque village of Guernica was targeted for bombing practice by Hitler's army. As townspeople ran from their homes in terror, machine guns cut them down. Some 1,600 civilians were killed or wounded on 27 April 1937. By the next month, the massacre was common knowledge. Few were more outraged than Picasso, who was then living in Paris.

Picasso's response was to paint the mural *Guernica,* which was exhibited in the Spanish Pavilion of the Paris Exposition that same year. The painting faced strong criticism initially but over time came to be recognized as perhaps Modern Art's most powerful antiwar statement. The mural is neither romantic nor realistic. It is abstract, figurative art that resonates with viewers regardless of their preferred artistic style. And it was painted by the most influential artist of the twentieth century.

Pablo Ruiz y Picasso was born in Malaga, Spain, although he spent much of his life living in self-imposed exile in France. (The Musée Picasso in the Marais district of Paris at 5, rue de Thorigny, occupies a seventeenth-century hotel and holds a significant collection of the artist's works.) He became the most recognized figure in Modern Art, not only for his paintings but also for his work in other media, such as sculpture and ceramics. With Georges Braque (1882–1963), in 1906 he invented Cubism, which led him to other experiments in abstraction. His career lasted into vigorous old age, as he was painting and making other artworks into his 90s. Every artist during the first three-quarters of the twentieth century could claim him as a contemporary.

Another Spanish artist provides an earlier example of artistic reaction to conflict. Francisco José Goya (y Lucientes) (1746–1828) was a court painter early in his career. But, like Picasso who would follow him, Goya did not confine his talent to painting. He also produced many drawings, engravings, and frescoes. Although he began in the Rococo style, he later worked in the emerging Neoclassical style, which featured less ornamentation. He also painted everything from portraits to genre paintings.

During the Napoleonic invasion and the war for Spanish independence, Goya served as a court painter to the French. His 1814 painting, **The Shootings of May Third 1808,** which portrays an execution by firing squad, and his series of etchings, *The Disasters of War,* mark this dark period. Both were controversial. The etching series, in fact, was not published until 1863, long after Goya's death in 1828.

Goya and Picasso both reacted strongly to events associated with conflict by creating artworks as antiwar statements. Other artists, mainly before the nineteenth and twentieth centuries, often painted the glories of war and the nobility of soldiering. Greek warriors, for instance, often were portrayed in noble battles on temple friezes, as freestanding statues, or on vessels such as amphorae (narrow-necked jugs) and kylikes (shallow, stemmed drinking cups). In more recent times, the tradition of glorifying war has lived on largely in propaganda art. But there also have been war artists who viewed themselves simply as chroniclers, neutral observers, and recorders. An example is Campbell Taylor (1874–1969), whose work is mainly documentary in character. An example is his **Herculaneum Dock, Liverpool,** a 1919 work done in ink and watercolor on paper.

In addition to real battles, mythology has supplied another source of conflict art. An example is **Fight, with Athena and Hermes Watching** (c. 525–520 B.C.), an amphora attributed to the Andokides Painter. Two armored warriors attack one another with spears as the goddess Athena and the god Hermes, flanking the warriors, look on.

During the great periods of biblical art, notably the Middle Ages and the Renaissance, many of the Bible's conflicts were rendered in art. Albrecht Dürer (1471–1528) provided numerous examples in his engravings and woodcuts, such as **St. Michael's Fight Against the Dragon,** a woodcut from 1498. The image is from a series of woodcuts illustrating the Revelation of St. John.

There also is implicit conflict—that is, conflict about to happen or just ended. For example, Michelangelo Buonarroti (1475–1564) and later Gianlorenzo Bernini (1598–1680) both sculpted the biblical David. Michelangelo's **David** (1501–1504) from the Renaissance period is brooding and still, readying himself for battle with the giant Goliath. Bernini's **David** (1623–1624), on the other hand, is from the Baroque period and

shows David in action at the very moment when he is about to launch the stone that will kill Goliath.

Sports, with their controlled forms of conflict, have provided art of a different sort. American painter George Bellows (1882–1925), for example, created a number of works about prizefighting. A well-known image is **Stag at Sharkey's** (1909), which shows two fighters locked in battle. Sports conflict of a different sort can be seen in the horse racing images of Impressionist Edgar Degas (1834–1917), such as **Before the Race** (c. 1882), which has the same sort of implicit conflict as Michelangelo's *David*, the jockeys on their mounts anticipating the contest ahead.

Another dimension of conflict is inner turmoil, or torments of the soul. Austrian Expressionist Egon Schiele (1890–1918) provides an example in his painting **Sitting Woman with Legs Drawn Up** (1917). The woman seems to be deep in thought, and her thoughts do not seem to be happy ones. The Norwegian Expressionist Edvard Munch (1863–1944) provides another example in his famous portrait of existential anguish, **The Scream** (or *The Cry*, 1893). Viewing this work, one can almost hear a horrible cry coming from the gaping mouth of the figure who clutches his skull-like head with both hands. Both of these examples come, appropriately enough, from German or Nordic Expressionism, a style that developed in the late nineteenth and early twentieth centuries, a period marked by numerous conflicts in Europe and elsewhere. Many Expressionist artworks portray some form of conflict, often emotional in character.

The art of English painter Francis Bacon (1909–1992) offers many examples of this Expressionist approach to conflict and existential angst extended into the Modern period. An example is his tortured **Self-Portrait** (1971), which may be compared to some of the self-portraits drawn and painted by Egon Schiele 60 or 70 years earlier. Bacon's work has been characterized as hallucinatory, sometimes satirical, sometimes horrific. The same can be said of much of conflict art.

VISUAL THINKING QUESTIONS

1. Conflict in one form or another is a central theme in literature and drama. Many of the conflicts found in novels and plays could be or have been illustrated in works of art. Given a particular piece of literature, what scenes might be chosen to illustrate the central conflict? Are there multiple scenes? Consider, for instance, in Shakespeare's *Romeo and Juliet* the fight scene between Romeo and Tybalt or the final scene of Juliet's emotional despair at finding Romeo dead.

2. Art often has been used to make powerful statements about the nature of conflict, whether the issue is civil rights or global war. Some celebrate conflict; others deplore it. In addition to visual images, how else have humans responded to conflict? Think about music, dance, the spoken word, and other forms of expression.

3. Sports competitions usually are forms of controlled conflict: individual against individual, team against team. Whether on the chessboard or the playing field, sports often provide a metaphor for war. How have sports been used in place of actual combat? Consider sports in various historical periods—for example, jousting in the Middle Ages or the modern Olympics.

SUGGESTED READING

Chenoweth, H. Avery. (2002). *Art of war: Eyewitness U.S. combat art from the revolution through the 20th century.* New York: Friedman/Fairfax.

Martin, Russell. (2002). *Picasso's war: The destruction of Guernica and the masterpiece that changed the world.* New York: E.P. Dutton.

Schmied, Wieland. (1997). *Francis Bacon: Commitment and conflict.* New York: Prestel.

ONLINE IMAGES

Before the Race (Degas)
www.ocaiw.com/galleria_degas/index.php?lang=en&gallery=cav&id=12

David (Bernini)
www.thais.it/scultura/image/sch00006.htm

David (Michelangelo)
www.bluffton.edu/~sullivanm/micheldavid/frontdet.jpg

Fight, with Athena and Hermes Watching (Andokides Painter)
www.goddess-athena.org/Museum/Paintings/Troy/Athena_Hermes _fight_Andocides_x.htm

Guernica (Picasso)
www.mala.bc.ca/~lanes/english/hemngway/picasso/guernica.htm

Herculaneum Dock, Liverpool (Taylor)
www.art-ww1.com/trame/054text.html

St. Michael's Fight Against the Dragon (Dürer)
 www.ibiblio.org/wm/paint/auth/durer/st-michel/st-michel.jpg

The Scream (Munch)
 www.ibiblio.org/wm/paint/auth/munch/munch.scream.jpg

Self-Portrait (Bacon)
 www.ibiblio.org/wm/paint/auth/bacon/selfport.jpg

The Shootings of May Third 1808 (Goya)
 www.ibiblio.org/wm/paint/auth/goya/goya.shootings-3-5-1808.jpg

Sitting Woman with Legs Drawn Up (Schiele)
 www.ibiblio.org/wm/paint/auth/schiele/schiele.sitting-woman.jpg

Stag at Sharkey's (Bellows)
 www.mystudios.com/gallery/discoveries/bellows_paints.html

5 Art and the Family

Throughout the centuries, artists have portrayed families, whether their own, those of their rulers, or others, from every level of society. One outstanding practitioner was American painter and printmaker Mary Cassatt (1844–1926). Several of her paintings were featured on U.S. postage stamps in 2003.

Cassatt grew up in Pennsylvania. Her parents were upper middle-class, and she was able to enroll in the Pennsylvania Academy of the Fine Arts in 1861. Soon after, she began traveling, taking a four-year trip through Europe, which began in 1865. Her travels allowed her to study in Spain, Italy, and France.

In 1868 Cassatt's painting *A Mandolin Player* was accepted by the Paris Salon, and by 1877 she had been noticed by Edgar Degas (1834–1917) and asked to join the Impressionists. This association led to changes in Cassatt's approach to painting. She abandoned the costume paintings of her early career in favor of the scenes of domestic life for which she is most remembered. Two well-known examples of Cassatt's paintings of family life are **La Toilette** (*The Bath,* 1891), which depicts a mother washing her child's feet in a basin, and **The Boating Party** (1893–1894), in which a mother and a child are being rowed in a boat by the father.

French artist Berthe Morisot (1841–1895), a contemporary of Cassatt and a friend of Impressionist painter Edouard Manet (1832–1883), was the first of the female Impressionists in the French circle to which Mary Cassatt later was invited. Morisot's family was wealthy, so she was educated in the usual upper-class manner in drawing and painting. But she went against convention, as did Cassatt, when she took up art as her life's work. She also painted family scenes, such as **La Lecture** (1869–1870), which depicts the

artist's mother and sister Edma. This painting and several of Cassatt's can be found in the National Gallery of Art in Washington, DC.

Women artists, like Morisot and Cassatt, began to take on larger roles in the art world in the late 1800s and early 1900s. But they were not alone in rendering scenes of family life. Male Impressionists also created artworks of such scenes. For example, Pierre-Auguste Renoir (1841–1919) painted many family scenes, including the widely reproduced **A Girl with a Watering Can** (1876). Incidentally, this Renoir painting also is in the National Gallery of Art in Washington, DC.

Indeed, family life, everyday settings, and people going about the business of living and working form much of the body of Impressionist art. But depictions of family life also were created in many other periods. Their value is twofold. On one hand, they provide viewers with a glimpse into how families lived in other times, their day-to-day activities, what they wore, what they ate, and so on. On the other hand, such family scenes also underscore or illustrate social distinctions, such as economic and cultural class differences and the status differences among men, women, and children.

In ancient Egypt, for example, women and children (and all lesser subjects) were portrayed as smaller than the pharaoh. Family members were depicted larger than their servants. The wall painting **Menna and His Family Fishing and Fowling** (c. 1400–1350 B.C.) from the tomb of Menna at Thebes is a good example. The family's servants are about half the size of the family members they serve.

That kind of image manipulation to show social status also is evident in other periods. In Romantic art, for example, the lower-class families and their activities tend to be prettied up to make them more acceptable to the middle- and upper-class art patrons. Romanticism coincided with the late Victorian era in England and was a reaction against Classicism, which was characterized by balance, harmony, and idealism of a different sort. Romanticism in art and literature, by contrast, was emotional, visionary, subjective, and even irrational.

Another way to approach family painting is through portraiture, particularly portraits of children, which can reveal much about family life (or, in some cases, family aspirations). American Realist painter John Singleton Copley (1738–1815) was the son of Irish immigrants who came to Boston. However, it was his meeting in 1755 with English artist Joseph Blackburn (c. 1700–1780) that influenced him to borrow the Rococo color palette and the technique of including everyday objects in his portraits. The latter strategy set him apart from many of his contemporaries who were painting portraits in Boston at that time. An example of his work is the painting of his half brother **Henry Pelham (Boy with a Squirrel)** (1765), which now hangs in

the Museum of Fine Arts in his hometown of Boston. Copley moved to London in 1775 and remained in England until his death. But his later historical paintings never gained him the fame that he garnered from his Boston portraits, which reveal much about life in colonial America and the aspirations of early American families.

The first half of the twentieth century ushered in three dramatic periods: the First World War, the Great Depression (not only in the United States but elsewhere), and the Second World War. These events stimulated many artists with a new sense of urgency and a new vision of the family, both as a unit and within the larger society. German Expressionist artist Käthe Kollwitz (1867–1945) lived in all three periods, dying shortly before the close of World War II. Her art often illustrates fatigue and the pain of suffering and loss. An example is her image of an exhausted woman in **Home Labor** (1925). This work and others can be seen in the private Käthe-Kollwitz-Museum in Berlin (online at www.dhm.de/museen/kollwitz/english/home.htm).

Yet another perspective: With the advent of photography, families could be portrayed easily and more directly. This ease allowed, for instance, the lower classes to be viewed more directly, without a Romantic filter. Again, women artists were among the leaders. Dorothea Lange (1895–1965) was one of the best. Perhaps her most famous photographic portrait is the one that has come to be known as **Migrant Mother** (1936), which shows a destitute 32-year-old mother with two of her seven children. The photograph is one of a series Lange made during the Great Depression. Her images not only convey the conditions of the period but poignantly portray the subjects' feelings as well. Lange also photographed a series showing Japanese families in the United States being transported to internment camps during World War II. A good example is **An Early Comer** (1942), which shows a neatly dressed Japanese boy waiting with the family belongings.

The influence of women artists is nowhere better seen than in family depictions. But women artists did much, much more than paint family scenes. An excellent resource for one to explore the contributions of women artists is the National Museum of Women in the Arts in Washington, DC (www.nmwa.org). Programs at the museum are designed to expand visitors' knowledge of women artists, composers, writers, musicians, actors, filmmakers, dancers, and women working in other creative disciplines.

VISUAL THINKING QUESTIONS

1. How has society's view of families changed since ancient times? Trace the major shifts in social and cultural viewpoints through historical

references, artistic expression, or literature. What about society's view of children? Trace similar shifts of perspective. Consider, for example, the evolution of child labor laws and changes regarding the age of maturity.

2. Do women artists do a better job of portraying the lives of women? What about in literature: Do female writers convey a keener sense of the realities of women's lives? To what extent do gender roles differentiate the viewpoints, experiences, and approaches to the work of men and women? Consider areas outside the arts: for example, Amelia Earhart in aviation, Marie Curie in science, or Golda Meir in politics.

3. Some historians might argue that in the twentieth century the family, both conceptually and practically, was more challenged and redefined than in any other historical period. In the visual arts, photography often has been used to document these challenges and changes. Identify some of the key issues or changes and find documentation, not only in photographs but in other forms, such as news reports, books or articles, motion pictures, and television programs.

SUGGESTED READING

Borhan, Pierre. (2002). *Dorothea Lange: The heart and mind of a photographer*. Boston: Bulfinch.
hooks, bell. (1995). *Art on my mind: Visual politics*. New York: New Press.
Pollock, Griselda. (1998). *Mary Cassatt: Painter of modern women*. New York: Thames and Hudson.

ONLINE IMAGES

The Boating Party (Cassatt)
www.ibiblio.org/wm/paint/auth/cassatt/boating.jpg

An Early Comer (Lange)
www.loc.gov/exhibits/wcf/images/wcf091.jpg

A Girl with a Watering Can (Renoir)
www.ibiblio.org/wm/paint/auth/renoir/watercan.jpg

Henry Pelham (Boy with a Squirrel) (Copley)
www.mfa.org/handbook/portrait.asp?id=304&s=1

Home Labor (Kollwitz)
 www.dhm.de/museen/kollwitz/english/homelabour.htm

La Lecture (Morisot)
 www.ibiblio.org/wm/paint/auth/morisot/reading.jpg

La Toilette (Cassatt)
 www.ibiblio.org/wm/paint/auth/cassatt/toilette.jpg

Menna and His Family Fishing and Fowling (Egypt, Eighteenth Dynasty)
 www.metmuseum.org/explore/newegypt/htm/cr_frame.htm

Migrant Mother (Lange)
 memory.loc.gov/pnp/fsa/8b29000/8b29500/8b29516r.jpg

6 Art and History

Historians, other writers (such as novelists), and artists not only are recorders of history but also interpreters. What is recorded and how it is set down shape readers' and viewers' beliefs about historical persons and events.

In the late eighteenth and early nineteenth centuries, French painter Jacques-Louis David (1748–1825) was one of the most influential historical painters in Europe. David exemplified the Neoclassical style of the age, having come to it after studying in Rome where the Classical Revival was under way. From the time he returned to Paris in 1780, he gained fame for his grand treatments of historical events, such as **The Death of Socrates** (1787), which now hangs in New York's Metropolitan Museum of Art.

However, David was far more than merely a painter of ancient history. He also was politically active as a Jacobin and an ally of Robespierre. During the French Revolution he became a deputy and voted for the deaths of Louis XVI and Marie Antoinette. He even sketched the queen on her way to the guillotine. (The sketch is now in the Louvre Museum in Paris.) Indeed, he became the acknowledged painter of the revolution. His "martyrs of the revolution" series includes three paintings, probably the best known being **Marat Assassinated** (also called *The Death of Marat*, 1793), which portrays the revolutionary theorist Jean-Paul Marat dead in his bath.

With the fall of Robespierre in 1794, David himself was imprisoned and released only in response to pleas by his wife, an ardent royalist, who had divorced David during the revolutionary period. They remarried in 1796, and David's fortunes began once again to rise. He became a strong supporter of Napoleon, who appointed him to be his official painter. Among the notable works from this period are the famous portrait of the emperor on a rearing horse called **Napoleon at St. Bernard** (1800) and **Napoleon in His Study** (1812). The latter painting hangs in the National

Gallery of Art in Washington, DC. David's career suffered a final setback with the fall of Napoleon, and the artist went into exile in Brussels.

Of course, not all historical artists are as personally caught up in momentous events as David was. Many, particularly in earlier times, labored anonymously; and such art was not confined to painting on canvas. We know much about Egyptian history, for example, from scenes incised and painted in tombs. Friezes on Greek temples, such as the **Battle Between Greeks and Persians** (427–424 B.C.) on the Temple of Athena Nike that stands on the Acropolis in Athens, show famous battles, processions, and other events. And Roman Empire-era relief carvings and illustrated columns, such as **Trajan's Column** (113 A.D.) that stands in the Forum in Rome, recount the exploits of emperors. Historians also can learn about ancient events through numismatics, the study of coins and medals. Greek and Roman officials issued coins to mark important events, such as a battle or a visit by the emperor. A fascinating Web site, Ancient Greek and Roman Coins, can be found at http://dougsmith.ancients.info to pursue this line of artistry.

Jacques-Louis David painted both events long past and events of his day. Since the invention of the camera, however, most contemporary events of note have been recorded photographically. Photojournalism is primarily utilitarian and ephemeral, but many news photos can be viewed in retrospect as art and history as well. For example, Oshkosh, Wisconsin–born Lewis Wickes Hine (1874–1940) documented the labors of U.S. workers in the first half of the twentieth century in memorable photographs, such as **Worker Hanging onto Two Steel Beams** (1930–1931, taken during construction of the Empire State Building in New York City) and, from a series on child labor, **Garment Workers, New York, NY** (1908).

Margaret Bourke-White (1904–1971) went to college to study reptiles but ended up capturing some of the most compelling photographic images of the twentieth century. A forerunner in the emerging field of photojournalism, she was hired as the first staff photographer of *Fortune* magazine. In 1930 she was the first American photographer allowed into the Soviet Union. Later she was the founding photographer at *Life*, shooting the magazine's first cover in 1936. She roamed the world, photographing people, places, and events and creating images that sear into memory, from the devastation of World War II in **Nuremberg After Allied Bombing** (Germany, 1945) to hope for peace and nonviolence in **Gandhi** (at his spinning wheel in India, 1946).

At the same time, it should be said that historical painting of the contemporary scene did not totally vanish with the advent of photography. *Social Realism* is the name given to the art movement in the early twentieth century, particularly during the Great Depression era, whose

practitioners strove to portray social problems and hardships of everyday life. The *realism* in the movement's name refers to subject matter, rather than style. Many Social Realists painted in the abstract styles associated with Modernism.

An exemplar of Social Realism is African-American artist Jacob Lawrence (1917–2000). Lawrence was a member of the Harlem Renaissance. His works range from **The Street** (1957), which shows a group of women doting on a baby in a carriage, to his civil rights-era portrait of **Stokely Carmichael** (c. 1966), who was then chairman of the Student Nonviolent Coordinating Committee. The Carmichael portrait was commissioned for the cover of *Time* magazine, but it was never published, likely because the editors viewed it as being too controversial.

What we know of history, we learn from words and images. And what we record of today's events in words and images will be the subject matter of future historians.

VISUAL THINKING QUESTIONS

1. Choose a historical scene—David's *The Death of Socrates* or a Margaret Bourke-White photograph, for example—and assume the role of historical writer. How would you describe the scene itself? Delve into the background of the pictured event: What led up to it? And then, what followed? What were the consequences?

2. Social Realism portrays daily life, although often with an emphasis on hardships. Consider looking through the lens of Social Realism at some ancient period. What do tomb paintings, mosaics, friezes, or archeological sites (such as Pompeii) tell us about life in those times and places of the past?

3. Jacques-Louis David and Jacob Lawrence are examples of artists as activists, not only recording the contemporary scene for historical purposes but also participating in the social and political events they captured on paper and canvas. What are the ethics of this dual involvement? What are the merits and limitations of objective versus subjective historical art?

SUGGESTED READING

Beard, Mary, & Henderson, John. (2001). *Classical art: From Greece to Rome.* Oxford, UK: Oxford Press.

Lajer-Burcharth, Ewa. (1999). *Necklines: The art of Jacques-Louis David after the terror.* New Haven, CT: Yale University Press.

Stromberg, John. (1998). *Power and paper: Margaret Bourke-White, modernity, and the documentary mode.* Boston: Boston University Art Gallery/ University of Washington Press.

ONLINE IMAGES

Battle Between Greeks and Persians (Greece, 427–424 B.C.)
rubens.anu.edu.au/htdocs/laserdisk/classical/0001/152.jpg

The Death of Socrates (David)
www.ibiblio.org/wm/paint/auth/david/socrates.jpg

Gandhi (Bourke-White)
www.gallerym.com/pixs/photogs/mbw/pages/6_gandhi_india_1946
.htm

Garment Workers, New York, NY (Hine)
media.nara.gov/media/images/3/3/03-0234a.gif

Marat Assassinated (David)
www.ibiblio.org/wm/paint/auth/david/marat.jpg

Napoleon at St. Bernard (David)
www.ibiblio.org/wm/paint/auth/david/st-bernard.jpg

Napoleon in His Study (David)
www.ibiblio.org/wm/paint/auth/david/napoleon-study.jpg

Nuremburg After Allied Bombing (Bourke-White)
www.gallerym.com/pixs/photogs/mbw/pages/nuremberg_allied_
bombing_19.htm

Stokely Carmichael (Lawrence)
www.npg.si.edu/cexh/eye/html/l_carmichael.htm

The Street (Lawrence)
www.butlerart.com/pc_book/pages/jacob_lawrence_b.htm

Trajan's Column (Rome, 113 A.D.)
www.geocities.com/Athens/Pantheon/9013/Trajan.html

Worker Hanging onto Two Steel Beams (Hine)
www.nypl.org/research/chss/spe/art/photo/hinex/empire/hang
ing.html

7 Art and Industry

The Industrial Revolution, which began in the late eighteenth century, provided new subject matter for artists, many of whom took an absorbing interest in portraying workers, workplaces, and the general character of newly industrializing urban centers, whether London, Paris, or New York City. Other artists took on more intimate roles with respect to industry and commerce by designing the workplaces themselves.

In the first half of the twentieth century, one outstanding example was the Finnish-American architect Eero Saarinen (1910–1961), who is probably best known for his **TWA Terminal** (1956–1962) at New York's John F. Kennedy Airport. The terminal's bold, stylized organic forms are emblematic of Modern Art at mid-twentieth century.

Saarinen was born in Kirkkonummi, Finland, in 1910, but his family immigrated to the United States in 1923. His father was a sculptor, a career that young Eero also pursued initially. Thus, it is not surprising that his buildings have a sculptural quality even as they use the devices of Modern architecture, such as cantilevering. (A cantilever is a projecting structure that is supported at one end but carries its load at the other end or along its length. This device is a seminal feature of Modern architecture as the arch was to Medieval and Renaissance architecture. The relatively low Roman arch became a defining development during those later periods, when ever greater innovation produced the soaring vaults of the Romanesque and Gothic.) Among other projects, Saarinen also designed the Dulles Airport at Chantilly, Virginia, and one of the world's most recognizable monuments, the Gateway Arch in St. Louis, Missouri.

Architecture for the workplace is the tangible manifestation of a society's industrial and commercial goals, as well as a window on the workings of the business world within that society during the period in which the building was constructed. Saarinen's TWA Terminal, completed in 1962 shortly after the architect's death, is a case in point. At the time of

its completion, it was the most modern representation of the commercial air age—and symbolized America's hopes and dreams for air travel. TWA had already made a name for itself by being the first airline to offer all-air coast-to-coast service across the United States. The launch of a Russian Sputnik satellite in 1957 had initiated the space race, and regular passenger service to Europe by jet had begun in 1958. And so Saarinen's TWA Terminal, responding to these events, was very much an idealized vision as well as a practical workplace.

Stepping back in time, one can perhaps understand modern industrial and commercial architecture more clearly by looking at its evolution. A good starting point, particularly in the United States, is the work of architect Louis Sullivan (1856–1924), many of whose buildings can still be seen in Chicago, Illinois. Sullivan has been called the "father of the skyscraper" for his introduction of steel-frame construction and his dictum, which became the mantra of Modern architecture, "form follows function." Steel framing allowed architects to design taller buildings than previously had been possible and set the stage for the construction of ever taller skyscrapers during the second half of the twentieth century.

A notable Sullivan example is the **Carson, Pirie, Scott and Company Building** (1898–1899). One of the most important structures in early Modern architecture, this building also is distinguished for its modular construction. By working with modules, one or several at a time, a large-scale project can be completed more quickly. Sullivan developed this commercial building originally as a Schlesinger and Mayer department store. In addition to its construction, this building, like many of Sullivan's buildings, also is noteworthy for its ornamentation. The Art Nouveau-inspired designs on the lower two stories are cast in iron, and yet they are fluid and graceful.

Another architect associated with Chicago is the German-born Ludwig Mies van der Rohe (1886–1969), who worked in Germany and was associated with the Bauhaus movement. In fact, he directed the Bauhaus school of design from 1930 to 1933, until its closing with the rise of Nazism. In 1938 he was persuaded to take on the task of directing the architectural program at the Armour Institute of Technology on Chicago's near south side, and later he developed the master plan (and designed some 20 buildings) for the Illinois Institute of Technology. **Crown Hall** (1950–1956), on that campus, is an example of the spare, functional style that characterizes much of Mies van der Rohe's work and is an example of the glass-and-steel variety of Modern architecture seen mostly in the late 1950s, 1960s, and early 1970s.

Finally, among the architectural luminaries, also often associated with Chicago, is the quintessential American architect, Frank Lloyd Wright

(1867–1959). Among the many projects of his 70-year career, Wright built 25 structures in the Chicago suburb of Oak Park between 1889 and 1909, many of them private homes, through which he perfected the lean, low PrairieStyle for which he is known. But Wright also interpreted his style in commercial buildings. A noteworthy example is north of Chicago in the Wisconsin city of Racine, where he built the first cantilevered skyscraper, the **S.C. Johnson Research Tower** (1944). Wright, incidentally, began his career working as a draftsman for the firm of Louis Sullivan.

Turning to a few portrayals of scenes of industry and symbols of commerce, a good example is a railway painting by French Impressionist Claude Monet (1840–1926) titled **Arrival of the Normandy Train, Gare Saint-Lazare** (1877). (This painting is an apt segue because it also has a connection to Chicago; it hangs in the Chicago Art Institute.) During the second half of the nineteenth century, rail travel was what air travel came to be in the twentieth century. Increasing ease of mobility—moving people and goods quickly over long distances—stimulated the growth of industry and sped up urbanization. In this painting, a steam locomotive arrives at one of the large Paris train stations. Like many industrial paintings, it is full of black iron and smoke. Monet, who is probably better recognized for such paintings as his water lily series, also caught the bug of industry and painted the Gare Saint-Lazare seven times. Incidentally, another Paris train station, the Gare d'Orsay, is now the city's large Impressionist art museum, the Musée d'Orsay, which can be toured online at www.musee-orsay.fr.

In twentieth-century America, an example of an industrial painter is Emil Holzhauer (1887–1986), a German-American who became fascinated by industrial scenes, particularly in Brooklyn, New York. Holzhauer's work draws on German Expressionist imagery. His 1932 oil painting, **Machine Tender**, portrays an unnamed worker manning a black iron engine. His later painting, **The Quarry** (1955), puts stoneworkers in the foreground while behind them stand the abstracted buildings of a rock quarry. The story of Holzhauer also is a fascinating study of the artist's triumph over prejudice, which the German-born Holzhauer experienced in full force when he accepted a teaching position in the Deep South at the height of World War II.

Concurrent with the rise of industry was the development of the camera and various types of photography. Alfred Stieglitz (1864–1946) was the leading photographic artist of the late nineteenth and early twentieth centuries. He worked much of his life to set photography among the fine arts, and in 1924 reached the threshold when more than 20 of his photographs were displayed by the Metropolitan Museum of Art in New York City. From this beginning, photography gained increasing legitimacy as art. Stieglitz's gelatin silver print from 1910, **The City of Ambition**, shows newly

built skyscrapers, viewed across a stretch of water. The tall buildings stand out sharply amid smoking chimneys. The scene evokes a vision of the future, when skyscrapers would stretch to even greater heights. Stieglitz, who later married the painter Georgia O'Keeffe (1887–1986), set the standard for art photography in the twentieth century.

Finally, it seems only fitting to reflect on how the industrial age, which saw the introduction of new building techniques and advances in technological prowess, celebrated those attributes. Two examples serve to illustrate the contrast between the feats of the nineteenth century and those of the twentieth: the Eiffel Tower and the Gateway Arch.

The **Eiffel Tower** in Paris was designed by Alexandre-Gustave Eiffel (1832–1923), assisted by engineers Maurice Koechlin and Emile Nouguier and architect Stephen Sauvestre. The tower, which stretches to a height of 984 feet, took slightly more than two years to build (1887–1889). An example of Structural Expressionism, the tracery of iron, which was roundly criticized as well as praised at the time, was constructed for the Universal Exhibition in celebration of the centennial of the French Revolution. (The official Eiffel Tower Web site is www.tour-eiffel.fr.) French Expressionist Robert Delaunay (1885–1941) is one of many artists who repeatedly painted the Eiffel Tower, which is one of the most recognizable structures in the world. His **Eiffel Tower** (1909) is a good example.

For the Gateway Arch we come back to Eero Saarinen. At 630 feet, the **Gateway Arch** (1963–1967) is not as tall as the Eiffel Tower, but it is no less impressive as it rises from the western bank of the Mississippi River in downtown St. Louis, Missouri. The structure is a stainless steel arc, the base and sections of which are equilateral triangles. The site of the arch was selected in 1935 for a monument to commemorate the westward expansion of the United States. But it was not until 1947, shortly after the end of World War II, that a competition was held to select a design for the monument. Saarinen won the competition, although construction did not begin until 1963, two years after the architect's death. The arch was opened to the public in 1967. The Gateway Arch is part of the Jefferson National Expansion Memorial, online at www.nps.gov/jeff.

VISUAL THINKING QUESTIONS

1. Architecture is a rich mix of art (aesthetics, design) and science (mathematics, engineering, technology). Consider and investigate some of the technological advances that have made possible the construction of high-rise buildings (skyscrapers, for example) or look into the physics behind the cantilever. How does the arch found in a Gothic cathedral nave relate to the stainless steel structure of the Gateway Arch?

2. The history of a society, particularly since the advent of the Industrial Revolution, can be viewed through the lens of advancing industry. How has the industrialized world changed from its agriculturally based past? What evidence is there of this change in history, literature, and art?

3. Industry means labor. The change from farm labor to factory labor is itself a study of how the world has changed since 1800. Consider the labor movement: What are its manifestations? (See, for example, the Labor Arts virtual museum, online at www.laborarts.org.) What other societal changes (for example, the civil rights movement) are related to the labor movement?

SUGGESTED READING

Edwards, Audrey. (2001). *Emil Holzhauer: Portrait of an artist.* Pittsburgh, PA: Ceshore.

Roman, Antonio. (2003). *Eero Saarinen: An architecture of multiplicity.* New York: Princeton Architectural Press.

Willis, Carol. (1995). *Form follows finance: Skyscrapers and skylines in New York and Chicago.* New York: Princeton Architectural Press.

ONLINE IMAGES

Arrival of the Normandy Train, Gare Saint-Lazare (Monet)
www.artic.edu/artaccess/AA_Impressionist/pages/IMP_2.shtml

Carson, Pirie, Scott and Company Building (Sullivan)
www.ci.chi.il.us/Landmarks/C/Carsons2.html

The City of Ambition (Stieglitz)
www.philamuseum.org/collections/prints_drawings_photo/1949-18-47.shtml

Crown Hall (Mies van der Rohe)
www.ci.chi.il.us/Landmarks/C/CrownHall2.html

Eiffel Tower (Delaunay)
www.robert-delaunay.net/eiffeltower/et1.htm

Eiffel Tower (Sauvestre)
www.endex.com/gf/buildings/eiffel/etgallery/et1/eteastbw.jpg?x=51&y=25

Gateway Arch (Saarinen)
www.GreatBuildings.com/cgi-bin/gbi.cgi/Gateway_Arch.html/cid_
gateway_arch_001.gbi

Machine Tender (Holzhauer)
www.holzhauerart.com/indoil1.html

The Quarry (Holzhauer)
www.holzhauerart.com/indoil4.html

S. C. Johnson Research Tower (Wright)
www.delmars.com/wright/flw8-12.htm

TWA Terminal (Saarinen)
www.GreatBuildings.com/cgi-bin/gbi.cgi/TWA_at_New_York
.html/cid_twa_ny_mce_123_22.gbi

8 Art and Mathematics

The arts and sciences were far more closely intertwined in the past than they are today. Among the artists who were fascinated by mathematics was the Northern Renaissance master Albrecht Dürer (1471–1528). Dürer was born in the Imperial Free City of Nuremberg (*Nürnberg* in German) in the modern southern German state of Bavaria (*Bayern* in German). He followed an artistic tradition. His father, Albrecht Dürer the Elder, was a goldsmith who came to Germany from Hungary. Early in his life, young Albrecht was apprenticed to the Nuremberg painter Michael Wolgemut (c. 1434–1519). Although Dürer traveled extensively, he spent most of his life in Nuremberg, and his house in the Old Town section of the city is now a museum.

Like his somewhat older counterpart, the Italian Renaissance master Leonardo da Vinci (1452–1519), Dürer was interested in the theory of human proportions, perspective (an emerging science), and technology of all sorts, particularly machines of war. He undoubtedly was familiar with Leonardo's studies, having traveled in Italy as early as 1494, when he made the first of his sojourns in Venice. He also acquired a knowledge of the work of other artist-scientists, such as Piero della Francesca (c. 1420–1492), leader of the Umbrian school of painting who also was interested in perspective and had written on the subject. And he read the classics, notably Euclid, the Greek scholar who lived in the third century B.C.

About 1508 Dürer started to collect information on mathematics for a book, which in its complete form would never be published. But portions of this work were used in other books, such as his *Course in the Art of Measurement* (1525)—an introduction to geometry and perspective—and the posthumously published *Four Books on Human Proportion* (1528). His 1525 treatise includes the woodcut, **Demonstration of Perspective**, in which

two men are shown drawing a lute using a mechanical device as a way of demonstrating the objective validity of perspective.

The first experiments in perspective are attributed to Filippo Brunelleschi (1377–1446)—sculptor, architect, and engineer—who is given credit for the invention of linear perspective nearly a century before Dürer. Brunelleschi, who would also design and build the octagonal dome of the Florence cathedral, painted what is considered the first accurate perspective image, a view of the cathedral Baptistery. Linear perspective is based on the visual phenomenon that objects appear to decrease in size the farther they are from the viewer. They do so according to the rules of geometry. In a drawing or painting, perspective most commonly uses one, two, or three "vanishing points." These are the points at which a composition's lines, whether visible or implied, converge at a distance. Any artist who hopes to render a subject with any degree of realism must understand perspective in order to avoid distortion.

The flatness and awkward planes of medieval paintings or American primitives, for example, occur because the artist either inadvertently or intentionally ignores the geometric rules that allow perspective drawing to create the illusion of three-dimensional depth in a two-dimensional image.

One of Dürer's most famous engravings is **Melancholia**, in which the winged figure of Melancholy symbolizes the depressed state of mind that robs artists of enthusiasm for work. Aristotle observed that such depression often afflicts talented people. Dürer surrounds his Melancholy with other symbols, many having to do with geometry, such as a compass, a polyhedron, and a sphere. The interesting polyhedron seems to consist of two equilateral triangles and six irregular pentagons. But this engraving is justly famous for a unique element: a magic square.

A magic square is an arrangement of integers in the form of a square, such that each column and row and each of the two major diagonals adds to the same sum. Figure 8.1 shows Dürer's magic square from *Melancholia*. It is interesting to note that the center cells in the bottom row give the date of the engraving, 1514.

The magic square dates back to ancient China. According to legend, the first magic square appeared on the back of a sacred tortoise that crawled from the Yellow River about 2200 B.C. Knowledge of magic squares spread to India about the eleventh century, and they were written about by the Japanese during the sixteenth century. Emanuel Moschopulus, a fifteenth-century Byzantine writer, apparently introduced magic squares to Europe. But it was Albrecht Dürer who is believed to have created the first original European magic square.

In the past, magic squares were supposed to possess mystical powers. Some were constructed to represent aspects of the zodiac. Carrying a magic square engraved on silver protected a person from the plague.

Figure 8.1 Dürer's Magic Square

16	3	2	13
5	10	11	8
9	6	7	12
4	15	14	1

Interest in magic squares revived during the past two centuries, and algebra and calculus have been applied by more recent square makers. Indeed, there are several different types of magic squares, each with its own rules of construction.

Dürer also was interested in another mathematical proposition, the so-called *golden section*. (The terms *golden mean* and *golden ratio* also are used.) Euclid's *Elements,* a collection of 13 books on geometry, shows how to calculate the golden section by dividing a line (AB) into two sections (AP, PB), so that AB:AP = AP:PB (see Figure 8.2). Euclid takes this up in Book VI, proposition 30.

This proportion later was associated with the Fibonacci sequence. Leonardo Fibonacci (c. 1175–1250) was the mathematician mainly responsible for displacing the use of Roman numerals with the publication of his *Liber abaci* (Book of Calculations), in which he stated that any number could be written using the Indian numerals 1 through 9 and the Arabic zero. He was a remarkable mathematician. The sequence named in his honor simply adds, after 0 and 1, the last two numbers to get the next:

(0, 1) 1, 2, 3, 5, 8, 13, 21, 34, 55, 89, 144, 233, 377, and so on

But the power of this sequence is considerable, both in mathematics and in nature. For example, flowers often have a Fibonacci number of petals. And many figures in architecture make use of Fibonacci relationships.

The golden section value is obtained by taking the ratio of successive terms in the Fibonacci sequence:

(1:1, 1:2) 2:3, 3:5, 5:8, 8:13, 13:21, and so on

Going along the sequence takes one increasingly closer to the golden section, which normally is denoted by the Greek letter *phi*. The Greeks used this value in architectural designs, such as the Parthenon. And *phi* also occurs often in geometry, for example, in the ratio of the side of a regular

Figure 8.2	Golden Section		
A		P	B

pentagon to its diagonal. By drawing all of the diagonals as they cut across one another, they also describe golden sections—and they describe the five-pointed star that appears on many of the world's flags, including those of the United States and the European Union.

Since antiquity, the golden section also has been used to describe human proportion. The ideal man can be measured according to the 3:5 ratio. The human head, measured from chin to crown, is the basic unit. The standing figure is eight heads tall, and the center of the figure—the navel—is at five eighths the height of the body. Thus the figure is proportioned according to the golden section.

In a more complex manner, human proportion is famously illustrated in a drawing by Leonardo da Vinci, called the **Vitruvian Man**, which appears in his sketchbook. The drawing takes its name from Marcus Vitruvius Pollio, a first-century B.C. Roman writer on architecture, who described architectural proportion as ideally being related to the proportions of a finely shaped human body. Leonardo faithfully reproduced the proportions suggested by Vitruvius Pollio.

These proportions have been given mathematical and mystical significance through the ages. Much religious symbolism found roots in the relationship between human and architectural proportion. And the notion of the navel as the center of the human body also was a focal point of early medical practice.

Dürer extended Leonardo's human proportion studies and compiled his knowledge in *Four Books on Human Proportion* (1528), published shortly after his death. The works of these two artist-scientists provide key starting points for the modern science of ergonomics.

VISUAL THINKING QUESTIONS

1. Although most people think about airline or car seats when ergonomics is mentioned, ergonomics actually is concerned with all manner of intersections between humans and their surroundings. What are some other applications of ergonomics and how do they relate to art and design in today's world?

2. One of the most common applications of the golden section is the 3- x 5-inch index card. Where else can this pervasive ideal proportion be found?

3. Fibonacci used rabbit breeding for his research question. Beginning with a pair of rabbits, if each month each productive (x_n) pair of rabbits bears a new pair that becomes productive after a month, how many rabbits will there be after a given number (n) of months? The formula below is the rule for generating Fibonacci numbers. Use this formula to determine how many rabbits there will be at the end of one year. (Assume that no rabbits ever die.)

$$x_{n+1} = x_n + x_{n-1}$$

SUGGESTED READING

Aikema, Bernard, & Brown, Beverly Louise. (Eds.). (2000). *Renaissance Venice and the north: Crosscurrents in the time of Bellini, Dürer, and Titian.* New York: Rizzoli.

Elam, Kimberly. (2001). *Geometry of design: Studies in proportion and composition.* New Jersey: Princeton Architectural Press.

Swetz, Frank J. (2001). *Legacy of the Luoshu: The mystical, mathematical meaning of the magic square of order three.* Chicago: Open Court.

ONLINE IMAGES

Demonstration of Perspective (Dürer)
 www.dartmouth.edu/~matc/math5.geometry/unit11/unit11.html

Melancholia (Dürer)
 www.ibiblio.org/wm/paint/auth/durer/engravings/melencolia-i.jpg

Vitruvian Man (Leonardo)
 www.aiwaz.net/Leonardo/image1.htm

9 Art and Nature

Throughout history, art and science have been partners in the study and recording of nature. It was only in the nineteenth century that art and science seemingly went in separate directions, although some would argue that the movement toward separation began in the 1400s with Gutenberg's invention of movable type and, thus, modern printing. This latter point aside, two more recent factors can be said to account for much of this divergence. The first, in education, was the definition and then separation of the disciplines as a system for organizing school curricula, which came about in the late 1800s. The second, also in the 1800s, was the invention of the camera, which became the tool of choice in most cases for recording natural phenomena, in place of sketches and paintings.

The artist most identified with nature study immediately prior to this divergence of art and science is John James Audubon (1785–1851). This future artist was born in Santo Domingo to a French naval captain who served in the American Revolution. Audubon was taken to France as a young child following the death of his mother, but he returned to America at age 18 to help manage family property near Philadelphia.

Although Audubon studied with the French Neoclassical painter Jacques-Louis David (1748–1825), he attained fame as an artist only after years of business failure. It was not until about 1820 that he decided to make the study and portrayal of American birds his lifework. Thus, after several successful exhibitions, he began work on his masterpiece, *The Birds of America*, which is all the more remarkable for the relatively brief period in which it was produced. Published posthumously in 1838, this landmark work, which is considered to be a classic work on ornithology, contains 435 hand-colored folio plates depicting some 1,065 life-size birds. **Turkey Buzzard** (plate 151) is only one example from this remarkable volume.

Today, one can find Audubon societies literally around the world, devoted to the preservation of birds, principally, and other wildlife.

Merely entering "Audubon" into an Internet search engine will produce a wealth of Web sites of local societies, a living testament to the power of one man's marriage of art and science. An excellent Web site for Audubon images is www.audubongalleries.com.

Audubon, though his art was definitive in the realm of ornithology, was following a long tradition of marrying art and the study of nature. The Italian Renaissance master, Leonardo da Vinci (1452–1519), studied the flight of birds, for example, as he looked into the possibility of making human flying machines. But, then, Leonardo's mind turned over many ideas, and so his nature study was similarly wide-ranging, from his **Studies of the Paw of a Dog or Wolf** (1490) to his pen-and-ink of **The Babe in the Womb** (1519), a cutaway drawing investigating the position of a human fetus in the mother's womb.

Northern Renaissance artist Albrecht Dürer (1471–1528) also made extensive studies of animals (including insects), plants, and the human body. Examples include his **Tuft of Cowslips** (1526), a highly accurate and detailed gouache painting, and the watercolor **Stag Beetle** (1505), among many others.

Half a world away and several centuries earlier, the Chinese Emperor Huizong (1082–1135, reigned 1101–1125) compiled a record of rare birds and flowers, exquisite objects, and important events in the form of hand-painted scrolls and accompanying poems. His **The Five-Colored Parakeet** (n.d.) shows the exotic bird perched on an apricot branch in the imperial garden. Each feather and petal is rendered in the meticulous style of academic court painting.

Indeed, until the advent of photography, most scientists and other learned individuals were taught (or taught themselves) to draw in order to accurately depict the natural phenomena they studied. (This was also true of explorers, military planners, and others who needed visual references for their work.)

Although scientists themselves are no longer required to be expert artists, the art of depicting natural phenomena through painting, drawing, and even sculpting is by no means extinct. Artists' renderings often are used in books, especially when there is a need to show a rare specimen or a cutaway view. In 1966 at the Smithsonian Institution, an organization was founded to foster professional standards and collegiality among nature artists. That group, the Guild of Natural Science Illustrators, maintains a Web site at www.gnsi.org that helps connect their worldwide membership.

To this point, the nature art in question has concerned close-up views: plants, paws, bugs, and the like. Another genre of nature artists has focused on a wider vision. These are the landscape artists who have

recorded the larger sweep of their world: hills and mountains, rivers, valleys, storms at sea, sunsets, ancient and modern structures, and whatever else the world offers up. Many of their images have been produced more to record the beauty or power of a scene than to study it, but they have nonetheless produced a record, albeit sometimes idealized.

In 1798, when Napoleon and his army landed in Egypt, he brought along artists as well as poets, scientists, and surveyors. The expedition was largely a military failure, but these collateral personnel returned to France with a wealth of information—enough for the 22-volume *Descriptions de L'Egypte,* which was the authoritative work on Egypt for nearly a century. (It was an officer in Napoleon's engineering corps who found the Rosetta stone that proved to be the key to deciphering ancient hieroglyphics.)

Among Napoleon's savants was artist and architect Dominique-Vivant Denon (1747–1825), whose illustrations of Egyptian desert scenes and temples became so popular that they were widely copied, including by the Sèvres porcelain factory for a dinner service called **Service Egyptien** (1811). Denon later became director-general of museums and was partly responsible for the design of the Vendôme Column, a monument to Napoleon.

In early America, George Catlin (1796–1872) ventured westward to record what he saw. Although he is perhaps most remembered for his portraits of Native Americans, Catlin also recorded the landscapes and the natural life of the frontier, giving Easterners glimpses into a world little known to them. An example is his **Buffalo Bull** (1832), painted while on an expedition to document the Indian tribes of the upper Missouri River. Catlin's paintings were widely reproduced.

The line between drawing or painting nature for the purpose of observation and study and turning to nature for artistic inspiration is decidedly fine in some cases. Clearly Audubon resides at one end of this continuum, studying nature and painting it (birds mainly) so that others might study nature from those images. One might argue that an artist such as American painter Georgia O'Keeffe (1887–1986) resides at the other. Certainly her large-scale paintings of flowers draw on nature for inspiration, but they also demonstrate her careful study of natural forms.

An example of this aspect of O'Keeffe's work is **White Rose with Larkspur**, a 40- × 30-inch oil painting on canvas. The painting was a favorite of the artist and hung in her bedroom in Abiquiu, New Mexico, until 1979, when she donated it to the Boston Museum of Fine Arts. This artist's works can be seen in museums the world over and in the Georgia O'Keeffe Museum in Santa Fe, New Mexico.

Making and studying art that depicts natural phenomena is one way to bridge the modern gap between art and science. Such art also acts as a gateway into the science.

VISUAL THINKING QUESTIONS

1. Chinese Emperor Huizong studied nature closely and then rendered it in paint and poetry. What are some other examples of artists or scientists combining art and science in the study of natural phenomena?

2. Consider the visual content of a typical science book (a library book or a textbook). Choose a representative chapter and examine the visual components. Did the book designer use photographs, tables or charts, drawings, or paintings? Why might the visual elements of a book help a reader understand the information more clearly?

3. Compare and contrast the utility of photography with that of drawing or painting in the scientific representation of natural phenomena. What can a photographer do that an artist cannot, and vice versa?

SUGGESTED READING

Audubon, John James. (1999). *John James Audubon: Writings and drawings* (Christoph Irmscher, Ed.). New York: Library of America.

Dürer, Albrecht. (2003). *Nature's artist: Plants and animals* (Victoria Salley, Intro.). New York: Prestel USA.

Lee, Jennifer B., & Mandelbaum, Miriam. (1999). *Seeing is believing: 700 years of scientific and medical illustration.* New York: New York Public Library.

ONLINE IMAGES

The Babe in the Womb (Leonardo)
www.royal.gov.uk/output/page613.asp

Buffalo Bull (Catlin)
www.archives.uc.edu/exhibits/catlin/catweb_buffalobull.html

The Five-Colored Parakeet (Huizong)
www.mfa.org/handbook/portrait.asp?id=123&s=3

Service Egyptien (Sèvres, after Denon)
www.thebritishmuseum.ac.uk (search on "Denon")

Stag Beetle (Dürer)
www.getty.edu/art/collections/objects/oz25.html

Studies of the Paw of a Dog or Wolf (Leonardo)
www.artfund.org/acq/artworkDetail4_5.asp?appref=2518

Tuft of Cowslips (Dürer)
www.nga.gov/cgi-bin/pimage?72938+0+0

Turkey Buzzard (Audubon)
www.audubongalleries.com/prints/prints.php?cat=birds&subcat=ha
vell&pg=1&itemnr=91151&ordernr=4367

White Rose with Larkspur (O'Keeffe)
www.mfa.org/handbook/portrait.asp?id=363&s=9

10 Art and Performance

The link between visual art and performance is transparent. After all, whether the performance is live theater, television, or motion pictures, artists must design the settings, the costumes, the makeup, and so forth. Sometimes, all of these arts come together in a single, extraordinary individual. Such was the case with French artist, writer, and filmmaker Jean Cocteau (1889–1963).

Born in Paris, Cocteau came to transcend several art "-isms" of his day: Dadaism, Surrealism, and Modernism. He wrote novels—*Thomas the Imposter* (1923) and *The Incorrigible Children* (1929)—and poetry and plays. He made films: the classic *Beauty and the Beast* (1946) and the Orphic trilogy, *The Blood of a Poet* (1930), *Orpheus* (1949), and *Testament of Orpheus* (1959). And he created a range of images in painting, graphic arts, and ceramics. Several of his paintings feature **Profiles** of human faces, and the five-pointed star was his signature device. There is an interesting Jean Cocteau Web site at www.netcomuk.co.uk/~lenin/JeanCocteau.html.

Cocteau's friends and collaborators included cinema stars (such as Jean Marais and Yul Brynner), artists (Pablo Picasso), composers (Igor Stravinsky and Erik Satie), singers (Edith Piaf), writers (Colette), and couturiers (Coco Chanel).

With Cocteau it is difficult to say which of his many talents dominated during his lifetime, although it is for his films that he is best remembered today. With other individuals, the distinction is clearer. Spanish Modernist Pablo Picasso (1881–1973), who spent much of his life in France, was first and foremost a painter. But, like his friend Cocteau, he also exercised his talents in other ways, including lending his eye and brush to the stage

design for the Cocteau-Satie ballet *Parade* in Paris in 1917. (Picasso's painting, **The Italian Girl**, dates from the same year.) American expatriate writer and art patron Gertrude Stein hailed Picasso's first Cubist stage design as "revolutionary."

A few years later, Picasso's contemporary, French Modern artist Henri Matisse (1869–1954) designed the stage setting and costumes for Diaghilev's ballet *The Nightingale*, which was set to the music of Stravinsky. In 1939 Matisse did the same for Léonide Massine's ballet *Rouge et Noir (Red and Black)*, which was set to the music of Shostakovich's first symphony. Matisse's painting, **Young Woman in a Blue Blouse**, also dates from 1939.

British Modern artist David Hockney (b. 1937), who is sometimes labeled a Pop artist although he rejects the designation, ventured into stage design in the 1970s. He created set and costume designs for Stravinsky's *The Rake's Progress* and Mozart's *The Magic Flute*. Hockney's 1967 painting, **A Bigger Splash,** is a good example of the kind of California-inspired work he was doing at roughly the same period.

Of course, sometimes it works the other way around: Someone who excels as a performer also does work of note in the visual arts. American jazz-pop singer Tony Bennett (also known as Antonio Benedetto, b. 1926) is known for his traditional paintings and prints. His watercolor, **San Francisco Still Life** (n.d.), is an appropriate example for a singer known for his rendition of "I Left My Heart in San Francisco." British pop-rock singer-composer Paul McCartney (b. 1942), who gained fame as one of the Fab Four (also known as the Beatles), also paints. McCartney's abstract acrylic painting, **Big Mountain Face** (1991), is an example of his work.

Among silver screen performers, American motion picture actor Tony Curtis (b. 1925) is a notable artist. His 1983–1984 abstract **Marilyn** is a remembrance of actress Marilyn Monroe, with whom Curtis starred in the 1959 film *Some Like It Hot*.

And then there is *performance art*, which is another matter altogether. According to the online free encyclopedia *Wikipedia*,

> Performance art is art where the actions of an individual or a group at a particular place and in a particular time in front of an audience constitute the work. It can happen anywhere, at any time, or for any length of time. Another way of understanding this is to say that performance art can be any situation that involves four basic elements: time, space, the performer's body and a relationship between performer and audience. It is opposed to painting or sculpture, for example, where an object constitutes the work.[1]

Performance art is ephemeral. Although it may be caught on film or audio- or videotape, there is a certain loss in translation to these media. Performance artist and theorist Allan Kaprow (b. 1927) coined the term *happening* to describe performance art with the creation and performance in 1959 of his *18 Happenings in 6 Parts*, which involved various performances and experiences, including slide projections, dances, and taste and odor sensations. *Avant-garde* and *conceptual art* are other terms often applied to this multidisciplinary art form. The e-zine (online magazine) *Performance Art News* is a good starting point for additional exploration of this topic. Its URL is members.tripod.com/~jackbowman/partnew.htm.

The latest update of performance art is the *flash mob*, a form that took shape in 2003 thanks to the Internet. A flash mob is a group of people, many unknown to one another, who gather for a seemingly spontaneous event. The gathering is coordinated, including a script, over the Internet. For example, a flash mob of some 200 people gathered at an appointed time in New York's Macy's department store in the ninth-floor rug department around a particular rug, all claiming that they lived together in a warehouse and were shopping for a "love rug." Flash mobs gather, perform, and quickly disperse, leaving a wake of amusement and consternation. Flashmob.com (http://flashmob.com) is a Web site devoted to the phenomenon.

French artist Marcel Duchamp (1887–1968), the "father" of Dadism, is sometimes considered to be the "grandfather" of conceptual art, or performance art, in which an idea matters more than its representation. Duchamp's 1913 *found art* construction, **Bicycle Wheel**, which consists of a bicycle wheel mounted on the seat of a wooden kitchen stool, is an example of his art.

The traditional performance arts—singing, acting—and visual arts share a common creative bond. And so it is not unusual for individuals involved in performance to make visual art and vice versa. Many creative individuals have the capacity to excel in a variety of arts. Performance and conceptual art take this bond a step further to create a wholly original art form.

VISUAL THINKING QUESTIONS

1. What human characteristics are associated with creativity? How are these characteristics applied in the visual arts? In the performance arts?

2. Consider the art of movie making. In addition to the creative aspects, what are the scientific and technological contributions that make possible or enhance the performance and visual arts of this endeavor?

3. Investigate the performance art phenomenon called a *flash mob*. What are the usual elements of a flash mob event ("performance")? Try writing a script for a flash mob or performance art event.

SUGGESTED READING

Goldberg, Roselee. (2001). *Performance art: From futurism to the present.* London: Thames and Hudson.

Kostelanetz, Richard. (2001). *Dictionary of the avant-gardes* (2nd ed.). New York: Routledge.

Steegmuller, Francis. (1992). *Cocteau: A biography.* Boston: David R. Godine. (Original work published 1970)

ONLINE IMAGES

Bicycle Wheel (Duchamp)
 www.beatmuseum.org/duchamp/images/bicycle.jpg

Big Mountain Face (McCartney)
 www.siegen-wittgenstein.de/kultur/pmc/indexb.htm

A Bigger Splash (Hockney)
 www.ibiblio.org/wm/paint/auth/hockney/splash/hockney.splash.jpg

The Italian Girl (Picasso)
 www.buehrle.ch/index.asp?lang=e&id_pic=138

Marilyn (Curtis)
 www.tonycurtis.com/view_master_frame.html

Profiles (Cocteau)
 www.leninimports.com/jcoctcardset1.jpg

San Francisco Still Life (Benedetto)
 www.benedettoarts.com/cgi/imageFolio.cgi?action=view&link=
 4-_Still_life&image=w1167.jpg&img=8&tt=

Young Woman in a Blue Blouse (Matisse)
 www.abcgallery.com/M/matisse/matisse155.html

Note

1. *Performance art.* (n.d.). Retrieved December 30, 2003, from http://en .wikipedia.org/wiki/Performance_art

11 Art and Place

Artistic expression often conveys a sense of place—place felt, place remembered, place imagined. It does not matter whether the visual portrayal is realistic, abstract, or symbolic. Rather, the portrayal must be evocative of the feel or emotional presence of the place, not merely its literal existence. For example, French Impressionist painter Claude Monet's (1840–1926) interpretations of London's Houses of Parliament convey a keen sense of the great building. In one of these paintings, the 1904 oil **Houses of Parliament, London, Sun Breaking Through Fog,** the great British landmark is seen across the Thames River through a haze that is just beginning to clear—a scene that speaks of both mystery and majesty that are consonant with the place itself, the literal seat of government and symbolically the heart of the free nation.

By contrast, American photographer Ansel Adams (1902–1984) uses sharp black-and-white photographs to convey a sense of place in many of his sweeping panoramic views. In **The Tetons - Snake River** (1942), for example, the magnificent mountain range rises in the distance, while in the foreground the shining river meanders along its course. The scene is both powerful and serene, fully evoking the natural grandeur of the wilderness that was, and to some extent still is, the American West.

Among the world's artists who have brought a strong sense of place to their art, one who particularly stands out is the Japanese master Ando (Utagawa) Hiroshige (1797–1858). Hiroshige, working as both painter and printmaker, took ordinary scenes and elevated them to the level of High Art by his attention to detail and composition. Everyday landscapes became lyrical scenes, uniquely commemorating their place, both within their own era—Hiroshige worked during the Edo Period—and in a universal way that transcends time.

Edo (now Tokyo) was a frequent subject of the *Ukiyo-e*, or popular, school of painting and printmaking, and Hiroshige was the school's last great practitioner. His teacher was Utagawa Toyohiro (1773–1828), whose name he adopted as part of his own. Hiroshige was a younger contemporary of Katsushika Hokusai (1760–1849). The wildly popular works of Hokusai and Hiroshige endure to this day, often as posters for college dorm rooms.

Hiroshige achieved his greatest successes as a landscape artist, mostly through the creation of colorful print series, such as his 1833 masterpiece *Fifty-Three Stations of the Tokaido*. This series portrays various scenes along the highway from Edo to Kyoto. Other series include *Celebrated Places in Japan*, *Sixty-Nine Stations on the Kiso Highway*, and *One Hundred Famous Views of Edo*. Some examples from this last series, created in 1857, include **Dyers' Quarter, Sanno Festival Procession at Kojimachi I-chome**, and **Ushimachi** (a harbor scene). The only complete set of *One Hundred Views of Edo* in the United States is part of the permanent collection of the Brooklyn Museum (online at www.brooklynmuseum.org).

About the same time that Hiroshige was working in Japan, English landscape artist Joseph Mallord William Turner (1775–1851), although largely self-taught, was turning his hand to creating ethereal landscapes and seascapes consistent with the style of the Romantic period. Turner found early acceptance while still in his teens and remained successful throughout his life. He was elected to the Royal Academy in his 20s. In many respects Turner was a precursor of the Impressionists. Often referred to as "the painter of light," he covered his canvases with light-filled, panoramic, and—especially in his later years—loosely rendered scenes. Their seeming spontaneity belies Turner's careful attention to detail. **Dido Building Carthage** (1815) exemplifies his early Romantic style, while **Slave Ship** (1840) is a good example of his later, more characteristically impressionistic style.

Working about 150 years earlier, another artist who created a sense of place in his paintings is Jan, or Johannes, Vermeer (1632–1675). Vermeer, a Dutch genre painter who lived and worked in Delft, created far more intimate scenes than did Hiroshige or Turner. Most of the 35 or so paintings attributed to Vermeer are interiors with only one or two people pictured. But each has an exquisite sense of place because of Vermeer's attention to detail and the naturalism of his scenes. In **The Music Lesson** (1662–1665), for example, a woman plays the piano while her male teacher looks on. Rather than portraying the woman face on, Vermeer placed the woman's back to the viewer. But he cleverly captured her face in a mirror that hangs above the piano. (Incidentally, a recent motion picture delved into the life and work of Vermeer and was titled after one of his rare portraits, *Girl with a Pearl Earring*.)

Finally, between Vermeer in the seventeenth century and Hiroshige and Turner largely in the nineteenth century, there is Canaletto in the eighteenth century. The Italian Giovanni Antonio Canal (1697–1768), best known by the diminutive Canaletto, became the most famous scenic painter of his century. Canaletto's father was a theatrical scene painter, a trade that Canaletto himself began to work in. But in his 20s he turned his artistry to painting scenes of his native Venice, and it is for those canvases that he is best known. His scenes, such as **The Piazzetta** (1733–1735) and **The Grand Canal at the Salute Church** (1738–1742), are accurate and minutely detailed. He often used a camera obscura to aid him in composing the scenes. (See Chapter 15 for more about this device.) It is the incredible detail—a feeling that the viewer could be right there, on that very spot—that gives Canaletto's paintings their heightened sense of place.

In summary, place is an elusive concept vastly open to individual interpretation. We have a sense, as viewers, when an artist gets it just right even though we may not be able to say why it is right. Writers likewise often work to create a sense of place, whether they are novelists creating imaginary places or historians recreating the settings of important events of the past. Place, whether in a visual art form or in writing, draws us in and engages us.

VISUAL THINKING QUESTIONS

1. Most people, if they think about it, have a special place. The place itself may be humble or grand, isolated or populated. The visual arts portray a sense of place in many ways, from Monet's hazy shapes and impressions to Canaletto's precise and intricate details. Put yourself in the role of a writer. Consider how a sense of place is conveyed in literature. How is place created and made memorable by Edgar Allen Poe, Mark Twain, or other writers? How might you, as a writer, portray your special place?

2. Hiroshige and Hokusai in Japan created series of views, often along well-traveled roads. Viewers of these series were the armchair travelers of their day. Think about the nature of scenic art, from series such as these to Ansel Adams's sweeping panoramic photographs, and then consider the options available to today's armchair travelers. Take time to sample a few, for example, by viewing a travelogue video or visiting place-oriented Web sites on the Internet. What features do these forms of vicarious travel have in common? What do viewers gain? What do they miss out on compared to actual travel?

3. John Brinckerhoff Jackson (see Suggested Reading) argues that urban environments make people more concerned about time and movement and less about place and permanence. Do you think this is true? Does it matter? If so, how? Is the proposition either/or, or might there be ways to create a sense of place and permanence that incorporates time and movement?

SUGGESTED READING

Jackson, John Brinckerhoff. (1996). *A sense of place, a sense of time.* New Haven, CT: Yale University Press.

Oka, Isaburo. (1997). *Hiroshige: Japan's great landscape artist.* (Stanleigh H. Jones, Trans.). New York: Kodansha International. (Original work published 1992)

Schama, Simon. (1995). *Landscape and memory.* New York: Knopf.

ONLINE IMAGES

Dido Building Carthage (Turner)
www.ibiblio.org/wm/paint/auth/turner/i/dido-carthage.jpg

Dyers' Quarter (Hiroshige)
www.ibiblio.org/wm/paint/auth/hiroshige/dyers.jpg

The Grand Canal at the Salute Church (Canaletto)
www.kfki.hu/~arthp/html/c/canalett/2/index.html

Houses of Parliament, London, Sun Breaking Through Fog (Monet)
www.ibiblio.org/wm/paint/auth/monet/parliament/parliament.jpg

The Music Lesson (Vermeer)
www.ibiblio.org/wm/paint/auth/vermeer/i/music-lesson.jpg

The Piazzetta (Canaletto)
www.kfki.hu/~arthp/html/c/canalett/1/index.html

Sanno Festival Procession at Kojimachi I-chome (Hiroshige)
www.ibiblio.org/wm/paint/auth/hiroshige/festival.jpg

Slave Ship (Turner)
www.bc.edu/bc_org/avp/cas/fnart/art/19th/painting/slaveship1.jpg

The Tetons - Snake River (Adams)
www.archives.gov/exhibit_hall/picturing_the_century/port_adams/
port_adams_img107.html

Ushimachi (Hiroshige)
www.ibiblio.org/wm/paint/auth/hiroshige/takanawa.jpg

12 Art and Proportion

To some degree, all art is concerned with proportion in its purest sense, that is, how shapes or objects relate to one another in order to form a composition. More specifically, German Northern Renaissance artist Albrecht Dürer (see Chapter 8) was concerned with human proportions and perspective, as was Leonardo da Vinci, the Italian Renaissance master. For a purely nonobjective look at proportion, however, the work of a more recent artist comes to mind, that of the Dutch Modernist Piet Mondrian (1872–1944).

Mondrian began his career painting landscapes, but after living in Paris before the First World War he adopted the style for which he is remembered. Although influenced by Cubism, Mondrian developed a taste for pure abstraction, or nonobjective art, which avoided any reference to real objects. This style, which he termed *Neoplasticism,* was refined in the 1920s with the creation of his paintings consisting of black lines and rectangles of primary colors. It was Mondrian's way of taking painting back to its most elemental: the arrangement of colors and shapes on a flat surface. (Additional examples of Neoplasticism can be found at www. neoplasticism.com.)

Composition in Red, Yellow and Blue (1921), painted near the start of this phase in his artistic life, and **Broadway Boogie Woogie** (1942–1943), completed a year before his death, are representative of Mondrian's geometric compositions. These works illustrate an abstract purity in which balance is rendered supremely important by the diminution of other attributes. Such balance cannot be achieved without careful attention to proportion.

Another realm of art in which proportion is supremely important is architecture, particularly the glass-and-steel period of Modern architecture. In many ways, the strict vertical and horizontal lines and the rectangles of windows and wall expanses echo the geometry of a Mondrian painting. Although we associate this style of architecture with the 1950s and 1960s, it has historical roots that parallel Mondrian's adoption of geometric abstraction. The clearest parallel is the Bauhaus movement in German architecture and design, which began with the founding of the Bauhaus school of art in 1919 in Weimar, Germany.

German architect Walter Gropius (1883–1969) was the founder of the Bauhaus, and the Bauhaus manifesto was that the ultimate aim of art is a building. Thus "bauhaus," a German word literally meaning "build" (*bau*) "house" (*haus*). The Bauhaus lasted until 1933, when the rise of fascism in Germany forced its closing. The final director of the school, from 1930 to 1933, was the well-known architect Ludwig Mies van der Rohe (1886–1969).

The **Gropius House** in Lincoln, Nebraska, is a good example of the geometric architecture illustrated in Walter Gropius's work and that of the Bauhaus architects and their disciples. When Gropius left Germany, he moved first to London and then settled in Boston and taught at Harvard University and the Massachusetts Institute of Technology (MIT). His work also was influenced by the writings of American architect Frank Lloyd Wright (1867–1959).

Ludwig Mies van der Rohe was a contemporary of Gropius and Wright. The building at **860–880 Lakeshore Drive** in Chicago, Illinois, is an example of Mies van der Rohe's work after he also immigrated to the United States. The twin towers, now landmarks, were built between 1949 and 1951. Again, the influence of geometric abstraction is evident. (See Chapter 7 for more about Mies van der Rohe.)

The style that developed in the Bauhaus and elsewhere in Europe and the United States during the 1920s and 1930s came to be called *International Style* and was characterized by stark geometric designs carried out in glass, steel, and reinforced concrete. This stylistic period lasted until the early 1970s and, although it predominated, other styles also flourished. For example, the work of architect Eero Saarinen (see Chapter 7) brought an organic quality to Modern architecture.

Modern artists and architects were not the first to be interested in proportion. Scholars have long believed that the pyramid builders of ancient Egypt worked diligently to incorporate accurate geometric proportions into their constructions as symbols of the divine nature of the universe. The **Great Pyramid** of Khufu (also known as Cheops), for example, which is believed to have been raised about 2589 B.C., originally stood 481 feet high with each side measured along the base being 754 feet. Age and wear make

absolutely accurate measurement impossible. The base-to-height ratio, translated into royal cubits, is 440:280, or approximately half the value of *pi*.

The appearance of *pi* in relation to the primary dimensions of the Great Pyramid is telling. The proportions of the pyramid also provide a side slope angle of 51 degrees, 52 minutes (51° 52′ ± 2′), again expressing a value of *pi*. In this case, the slope is close to $4/pi = 1.273$. The height in relation to a half side of the pyramid is a *golden section* (see Chapter 8), a ratio of 89:55, which is contained in the Fibonacci sequence: (0, 1) 2, 3, 5, 8, 13, 21, 34, 55, 89, 144. . . .

The ancient Greeks also devoted considerable attention to proportion. *Classical* proportion for temples, laid out on a rectangular plan surrounded by columns, dictated *x* columns on the short ends of the rectangle and *2x + 1* on the long sides. The **Parthenon** (447–438 B.C.) in Athens, probably the best-known example, has 8 columns on each end and 17 along each side. (See also the **Parthenon Floor Plan**.)

The **Eglise de la Madeleine** (Madeleine Church) in Paris, which was completed in 1842, is a replica of a Greek temple, modeled on the Parthenon. This Catholic church named for Mary Magdalene is an example of Neoclassical architecture, a stylistic period during which artists and architects turned to Greek and Roman antiquity for inspiration and models, much as did their counterparts in the Renaissance.

The formalized proportions and geometry of Greek and Roman architecture also were echoed in early buildings in the United States, particularly government buildings, such as the White House and the United States Capitol. But such buildings were not alone in taking their cue from antiquity. Thomas Jefferson's plan for the **Library** at the University of Virginia, built 1819–1826, drew on the general plan of the **Pantheon**, a temple in Rome, Italy, rebuilt on its current plan by the Emperor Hadrian from 118 to 126, following the destruction of an earlier temple by fire.

Interestingly, Jefferson never saw the Pantheon, but he knew of it through the writings of influential Italian Renaissance architect Andrea Palladio (1508–1580). Palladio's **Villa Capra** (or Villa Rotunda), built between 1566 and 1571 at Vincenza, Italy, is an example worth comparing to the University of Virginia Library or Jefferson's home at **Monticello**.

Although the path from the pyramids to Mondrian is far from straight, this brief excursion serves to point out the interest in geometry and proportion that has extended from ancient to modern times. The study of proportion has always been fundamental to art and architecture and, by extension, it has been and continues to be important in other areas of life, such as religion and government, where certain proportions have been used in art and architecture as symbolic representations.

VISUAL THINKING QUESTIONS

1. Mondrian and other proponents of Neoplasticism believed that art should be the expression of the absolutes, represented by vertical and horizontal lines and primary colors. What form might such a philosophy take in other creative endeavors, such as writing or acting?

2. In the nineteenth and early twentieth centuries many government buildings and financial institutions were built using designs that echoed Greek and Roman antiquity. Consider the symbolism of these buildings. What messages were the builders trying to convey?

3. In 1933 the Bauhaus school was closed on orders from the Nazi regime. Why did the fascist government oppose the Bauhaus? Research this question and then consider whether other historical parallels exist.

SUGGESTED READING

Faerna, Jose Maria. (1997). *Mondrian.* New York: Harry N. Abrams.
Girard, Xavier. (2003). *Bauhaus.* New York: Assouline.
Gromort, Georges. (2001). *The elements of classical architecture.* New York: W. W. Norton and Company.

ONLINE IMAGES

Broadway Boogie Woogie (Mondrian)
www.ibiblio.org/wm/paint/auth/mondrian/broadway.jpg

Composition in Red, Yellow and Blue (Mondrian)
www.ibiblio.org/wm/paint/auth/mondrian/ryb.jpg

Eglise de la Madeleine (Madeleine Church, front view)
www.library.northwestern.edu/spec/siege/images/PAR00338.JPG

Eglise de la Madeleine (Madeleine Church, side view)
www.library.northwestern.edu/spec/siege/images/PAR00913.JPG

860–880 Lakeshore Drive (Mies van der Rohe)
www.ci.chi.il.us/Landmarks/numbers/860880LSD2.html

Great Pyramid (ancient Egypt)
www.world-mysteries.com/mpl_2.htm#Geometry

Gropius House (Gropius)
 www.bc.edu/bc_org/avp/cas/fnart/fa267/gropius/gropius2.jpg

Library (University of Virginia, Jefferson)
 www.bc.edu/bc_org/avp/cas/fnart/fa267/jeffersn/uva4.jpg

Monticello (Jefferson)
 www.GreatBuildings.com/cgi-bin/gbi.cgi/Monticello.html/cid_
 120971.gbi

Pantheon (Rome, Hadrian)
 www.GreatBuildings.com/cgi-bin/gbi.cgi/Pantheon.html/cid_
 1349932.gbi

Parthenon (Ancient Greece)
 www.perseus.tufts.edu/cgi-bin/image?lookup=Perseus:image:
 1987.09.0276

Parthenon Floor Plan
 www.perseus.tufts.edu/cgi-bin/image?lookup=1990.33.0051a&type=
 plan

Villa Capra (Palladio)
 www.GreatBuildings.com/cgi-bin/gbi.cgi/Villa_Capra.html/cid_
 2462234.gbi

14 Art and Religion

A rt has been used for religious expression throughout history. Such expression ranges from simple storytelling to iconic veneration. Art provides a means to investigate the social, historical, and political dynamics associated with religion in various cultures and contexts.

In Western history, an artist particularly noteworthy for his religious artworks is the Italian Renaissance master Michelangelo Buonarroti (1475–1564) of Florence. He worked in sculpture, architecture, and reluctantly, albeit magnificently, in painting. Some of his most famous works are marble sculptures, such as the biblical **David** (1501–1504) and the figure of Mary and the crucified Christ called the **Pieta** (1498–1499). The former stands in the Accademia in Florence; the latter in the Vatican.

The Renaissance was an age when most artists were supported by commissions from patrons. No patron was more powerful than the Roman Catholic pope was. In Michelangelo's day, one of the most powerful popes was Julius II (1443–1513, pope 1503–1513), sometimes called the "warrior pope." Julius was determined to extend the temporal power of the papacy. He made war on Venice, restored territories to the Papal States, and even formed a Holy League (1510–1511) with the aim of freeing all of Italy from French control.

As much as Pope Julius II was a temporal and religious ruler, he also was a patron of the arts, which in that age meant art that glorified God. And he was not a person one would wish to offend. Although he was advised to the contrary, the pope decided to commission Michelangelo, who had little experience with painting, to paint the ceiling of the Sistine Chapel in the Vatican. Thus, in 1508, when he summoned Michelangelo to Rome, the artist did as he was bid even though he argued vehemently that

13 Art and Reality

Representational art refers to artworks—mainly paintings, drawings, prints, and sculptures—that present objects (including people) that are recognizable by the viewer. The term *abstract* is sometimes applied to nonrepresentational art, which emphasizes shape, color, texture, and other design characteristics without reference to an object. However, abstraction also refers to the process of changing a representation, and so there is abstract representational art as well. For example, the objects in Spanish artist Pablo Picasso's (1881–1973) painting **Girl Reading at a Table** (1934) clearly are not realistically rendered. But we can see that the scene includes a girl, a table, a lamp, a book, and so on. They are abstractions, but the painting is nonetheless a form of representational art.

This consideration of representation aptly leads to considering the nature of reality as presented in the visual arts. How reality is presented in the arts says much about the nature of experience at various times and in various places. What social, environmental, or political currents are shaping the realities of everyday life? The range of representation is vast, as is the range of reasons for altering representational reality. Only a few points can be illustrated in this short chapter, but they may serve as jumping off points for further investigation.

An artist particularly known for his manipulations of reality was Spanish painter Salvador Dali (1904–1989). Dali was identified with the Surrealists, a group of painters influenced by the writings of Sigmund Freud who attempted to portray the "reality" of the subconscious. Dali often attempted to present the dream world through the fantastical juxtaposition of objects rendered with a realistic touch. His most famous painting in this mode is **The Persistence of Memory** (1931) with its melting pocket watches.

In the late 1930s, Dali was influenced by the Italian Renaissance painter Raphael (1483–1520) and began to adopt a more academic style of painting. But he never abandoned Surrealism entirely, and that fact along with his penchant for the outrageous in his personal behavior kept him in the limelight until his death. Dali, who sported an extravagant mustache, was known as much for flamboyant self-promotion as for his excellence as a painter and his forays into theatrical design and filmmaking.

The Discovery of America by Christopher Columbus (1958–1959) is an example of the artist's later paintings. In this monumental (nearly 14 feet high) work, Dali combines images of Columbus, the crucified Christ, and Dali's wife Gala, who appears in several of his paintings. In the United States, the Salvador Dali Museum in St. Petersburg, Florida, keeps the artist's flame burning brightly. The museum celebrated the artist's centennial in 2004. Information and a virtual museum visit are online at www. salvadordalimuseum.org.

Artists in the Modern period are not the only ones to manipulate reality. The Dutch painter Hieronymus Bosch (1450–1516), an eccentric figure in the Late Gothic period, included fantastic beasts and demons in his paintings and juxtaposed the commonplace with the absurd. Many of his paintings are allegorical in nature. For example, **The Extraction of the Stone of Madness (The Cure of Folly)** (c. 1475–1480) shows a fairly common medieval operation, the excision of "stones" from the head of a man. In this case, however, the stone is a flower. Looking on are a monk and a nun or matron with a book balanced on her head.

Although Bosch is an outstanding figure, his use of the bizarre was not unusual in the art of the Middle Ages. Grotesque, demonic, or fantastic figures often held symbolic significance. For example, the **Water Spout Gargoyles** found on the famous Notre Dame de Paris cathedral, built between 1163 and 1250, not only carried away rain water from the building's roof but served to scare away evil spirits. (Technically, the functional waterspout figures are *gargoyles,* while the nonfunctional figures are *grotesques.*)

Another way to manipulate reality is to alter the relative scale of objects. The artists of ancient Egypt, for example, sculpted or painted figures according to their importance in the social hierarchy. The figure of a god or a pharaoh was the largest, with lesser officials, commoners, and slaves shown as smaller figures. In **The God Nun**, a relief carving at Abydos from the period 1290–1279 B.C., the large figure of the god is shown lifting up a solar barque, a boat bearing the sun (symbolized by a scarab beetle) and various, much smaller, human figures.

The art of the ancient Near East—for example, Mesopotamia: Sumer, Babylon, Assyria—shows scaling of figures similar to that in ancient

Egyptian art. A sample is the battle scene in the Neo-Assyrian relief carving **Siege of Lachich (Judah)** (c. 701 B.C.). This fragment from the Palace of Sennacherib at Nineveh (Kuyunjik), now in the British Museum in London, shows the Assyrian army attacking the enemy's fortress walls with a siege engine. The soldiers are portrayed as larger than the slaves who are helping them.

At what might be termed the opposite end of the range is the art movement called *Photorealism*, in which the painted or sculpted image seems to be as accurate and detailed as a photograph. Many Photorealist paintings are quite large, but regardless of size the object in Photorealism is to allow viewers to study the "reality" in close detail. This movement flourished in the 1960s and 1970s. American painter Chuck Close (b. 1940) provides an example with his **Frank** (1969), a large (108- × 84-inch, 9-feet-high × 7-feet-wide) canvas painted in acrylic paint. American sculptor Duane Hanson (1925–1996) provides a three-dimensional example in his life-size—and lifelike—**Salesman** (1992), which is made of painted polyvinyl and actual clothing. Hanson's figures stand in various museums, and it is not unusual for visitors to approach them with comments or questions before they realize that the figures are not alive.

What is reality? Artists throughout the ages have attempted to understand this question and to pose answers.

VISUAL THINKING QUESTIONS

1. In some ancient cultures—ancient Egypt among them—social status was shown by making more important personages larger and less important ones smaller in paintings and sculptures. How might that social scaling be applied in today's society? Who would be large? Who would be small? And why? For example, students might consider the groups within their school, such as administrators, teachers, "jocks," "nerds," and so forth.

2. Photorealism makes the viewer really examine the reality of the object, scene, or model. How might this kind of warts-and-all approach benefit the study of other disciplines, such as history? Is this sort of close examination truly objective? In what ways might it still be subjective?

3. Salvador Dali often painted the dreamworld, attempting by manipulating representation to make tangible the intangible. How do researchers and practitioners in other fields attempt to translate ideas into tangible matter? Consider, for example, how scientists work to prove theories or how historians attempt to recreate the past.

SUGGESTED READING

Descharnes, Robert, & Néret, Gilles. (2001). *Dali.* New York: Taschen America.

Hauser, Arnold. (1999). *The social history of art, volume 2: Renaissance, Mannerism, Baroque.* New York: Routledge and Kegan Paul.

Meisel, Louis K., & Chase, Linda. (2002). *Photorealism at the millennium.* New York: Harry N. Abrams.

ONLINE IMAGES

The Discovery of America by Christopher Columbus (Dali)
www.salvadordalimuseum.org/collection/classic/discovery_of_america.php

The Extraction of the Stone of Madness (Bosch)
www.ibiblio.org/wm/paint/auth/bosch/stone.jpg

Frank (Close)
www.artsmia.org/uia-bin/uia_doc.cgi/list/200?uf=mia_collection.ldb&key=paintings&noframes=x&hr=null&nd=355

Girl Reading at a Table (Picasso)
www.metmuseum.org/Works_of_Art/viewOnezoom.asp?dep=21&zoomFlag=0&viewmode=0&item=1996%2E403%2E1

The God Nun (ancient Egypt)
academic.memphis.edu/egypt/l0011.gif

The Persistence of Memory (Dali)
moma.org/collection/depts/paint_sculpt/blowups/paint_sculpt_016.html

Salesman (Hanson)
www.kemperart.org/permanent/works/Hanson.asp

Siege of Lachich (Judah) (Neo-Assyrian)
arthist.cla.umn.edu/aict/images/ancient/aneast/512/48.jpg

Water Spout Gargoyles (Notre Dame de Paris)
www.bluffton.edu/~sullivanm/ndame/spouts.jpg

he was neither qualified nor interested in painting. Nevertheless, Michelangelo's **Sistine Ceiling** (1509–1512) is one of the greatest master-pieces of that age or any other.

The famous fresco depicts nine biblical stories, including the famous central *Creation of Adam*. The Sistine Chapel itself is a simple vaulted rec-tangle, the dimensions of which (40 × 130 feet) are designed to repeat those given in the Bible for the Temple of Solomon. The ceiling at its highest point is some 60 feet above the floor. Michelangelo's painting spans the entire ceiling, more than 5,000 square feet. Pope Julius II lived to see the magnifi-cent ceiling fresco but died a few months later and was buried near the Colosseum in the church of St. Peter in Chains. Michelangelo's heroic mar-ble sculpture of **Moses** (1515) is a central figure decorating the pope's tomb.

Western religious art, particularly before the Renaissance, and reli-gious art in Asia, Africa, and elsewhere usually has been created by anony-mous artists. However, a few ancient names are remembered, such as the Greek Praxiteles (c. 370–330 B.C.) of Athens.

In Asia, particularly China, religions such as Taoism, Confucianism, and Buddhism have rich artistic traditions that include architecture, sculp-ture, printmaking, and painting. Examples can be found throughout the world's museums. One such example is a **Seated Buddha** (c. 650), a wood sculpture dating from early in the Tang Dynasty (618–905 A.D.) in China. This example still bears traces of gilt and polychrome pigments. Like many such examples, it once was colorfully painted.

Japanese scroll painting (usually ink on paper or silk) also portrays religious images, such as **Daruma** (n.d.) by the Japanese master Hakuin Ekaku (1685–1768). His direct style of painting represents the essence of Zen Buddhism.

Taoism, Confucianism, and Buddhism also spurred the development of another art form: theatrical drama. In the early centuries such dramas were full of gods and mystical beings, often represented on stage in a manner sim-ilar to their representation in paintings and sculptures. Classical Chinese theater, which developed during the Yuan Dynasty (1260–1328), arose from stories that often embodied Confucian ethics and Taoist mysticism. Until the nineteenth century, Chinese dramas did not contain dialogue as we know it. Rather there were declamations, music, and pantomime.

In India, early Sanskrit dramas often were based on religious texts from classical Hindu literature. These dramas, performed in palaces, were highly stylized in costume and gesture and prominently included music and dance. The form flourished between 1500 B.C. and 1100 A.D. Visual arts counterparts to this theatrical artistic expression can be found in Hindu art—for example, the dramatic mudstone sculpture, **The Goddess Durga Killing the Buffalo Demon, Mahisha** (Pala period, c. 700–1200, probably

twelfth century). Durga is portrayed as a 16-armed warrior slaying a water buffalo possessed by the demon Mahisha.

Religious drama in Europe also flourished early on. In ancient Greece and Rome, classical drama often incorporated gods and goddesses. With the advent of the Christian era, morality plays became a prevailing form of theater. Medieval drama consisted of passions, mystery plays, and church plays drawn from Scripture. They were performed in village squares, in streets, and at fairs. The actors often were priests and monks. About 1400, the first playhouse appeared in Paris to provide a permanent shelter for religious plays.

The plays of the Middle Ages find echoes in the anonymous religious works, such as altarpieces, of the period. A later example, for which the artist is known, is **The St. Denis Altarpiece** (1415), painted by Henri Bellechose (c. 1415–1440). The painting depicts the martyrdom of St. Denis in conjunction with the crucifixion of Christ. The bright gold background is characteristic of medieval religious paintings.

At certain times, religious paintings provide insights into the dress and manners of the period not that they depict but in which they were painted. The effect is similar to Shakespeare's *Hamlet* played in modern dress. An example is a painting by the late-medieval Dutch artist Hieronymus Bosch (c. 1450–1516), who is mentioned in Chapter 13. The painting is titled **Christ Carrying the Cross** (1490). Christ's demonic, fantastical tormentors wear the dress of Bosch's day.

As much as religious art is about the religion it represents, it also is about the time in which it is created and the social, political, historical, and philosophical currents at work not only to influence religion but also to affect how religion is expressed through art.

VISUAL THINKING QUESTIONS

1. Many religious artworks are narrative. For example, much of the religious art created in the Middle Ages was intended to tell biblical stories because most people during that time could not read or write. Can art still be narrative in quality today, even though most people are literate? What other types of art have a narrative quality? Consider, for example, propagandist art. What is the narrative, and how does that narrative reflect the contemporary scene?

2. Patronage has often been a driving force behind the creation and collection of great art. Two examples are Pope Julius II, who was Michelangelo's patron, and the Medici family in Florence, Leonardo da Vinci's patrons. How have other patrons of the arts—such as Gertrude and Leo Stein or

J. Paul Getty—influenced art and artists? How has such patronage been felt beyond the visual arts?

3. In some cultures religious drama or theater has been a precursor to secular theater. Choose a theatrical tradition and consider the following: (a) Is there a transition point when the predominance of religious drama gives way to secular drama? (b) If so, what are the driving forces—social, political, cultural—behind the transition? (c) Is there a connection between religious theater and religious visual arts at the time? (d) If so, does the connection remain between art and theater after the transition to secular drama?

SUGGESTED READING

King, Ross. (2003). *Michelangelo and the pope's ceiling.* New York: Penguin.
Morgan, David. (1999). *Religious piety: A history and theory of popular religious images.* Berkeley: University of California Press.
Plate, S. Brent. (2002). *Religion, art, and visual culture: A cross-cultural reader.* New York: Palgrave.

ONLINE IMAGES

Christ Carrying the Cross (Bosch)
 www.ibiblio.org/wm/paint/auth/bosch/carrying/carrying.jpg

Daruma (Hakuin)
 www.lacma.org/art/perm_col/japanese/painting/daruma.htm

David (Michelangelo)
 www.bc.edu/bc_org/avp/cas/fnart/art/ren_italy/sculpture/10_97_5_21.jpg

The Goddess Durga Killing the Buffalo Demon, Mahisha (Pala period, India)
 www.metmuseum.org/works_of_art/viewOnezoom.asp?dep=6&zoomFlag=0&viewmode=0&item=1993%2E7

Moses (Michelangelo)
 gallery.euroweb.hu/html/m/michelan/1sculptu/giulio_2/moses.html

Pieta (Michelangelo)
 www.christusrex.org/www1/citta/0-Pieta.jpg

The St. Denis Altarpiece (Bellechose)
www.louvre.fr/img/photos/collec/peint/grande/mi0674.jpg

Seated Buddha (Tang Dynasty, China)
www.metmuseum.org/works_of_art/viewOnezoom.asp?dep=6&zoom
Flag=0&viewmode=0&item=19%2E186

Sistine Ceiling (Michelangelo)
www.christusrex.org/www1/sistine/0B-Ceiling.jpg

15 Art and Technology

The Renaissance, which began in Italy in the fifteenth century and spread northward across Europe, generated a tremendous amount of interest in and experimentation with devices to extend human (or animal) strength, power, and capacity—in short, technology. The number of inventions proposed and realized during this period was enormous, touching on every area of endeavor, from the battlefield to the art studio.

Among the greatest of the Renaissance artist-technologists was Filippo Brunelleschi (1377–1446) of Florence, Italy. Brunelleschi—or "Pippo," as he was called by nearly everyone—trained initially as a goldsmith, one of the most prestigious artistic pursuits. This grounding gave him a keen eye, which he also turned to larger sculptural projects. He gained notice in 1401 by winning the design competition for the second bronze door of the Florence cathedral Baptistery with fellow artist (and arch rival) Lorenzo Ghiberti (1378–1455), who was commissioned to carry out the project.

During his apprenticeship as a goldsmith, Brunelleschi also developed an interest in wheels, gears, and weights, which led him to make a number of clocks. One of these, it is said, even contained a bell, making it the first alarm clock. But no evidence of this technological achievement has survived.

Brunelleschi left Florence after 1401 to sojourn in Rome, where he studied sculpture and architecture with another Renaissance great, the sculptor Donatello (Donato di Niccolò di Betto Bardi, c. 1386–1466). But Brunelleschi's hometown of Florence was never far from his mind. Soon he became caught up in the construction of the Florence cathedral, Santa Maria del Fiore (Holy Mary of the Flower, an allusion to the lily that is the symbol of Florence).

The cathedral's basic design was set by Arnolfo di Cambio (1245–1310) at the end of the thirteenth century, but the project would take some six centuries to complete, with the final decoration of the facade being done in the 1800s. However, it was the **Dome** that was seen in Brunelleschi's day to be the crowning achievement. In fact, in Arnolfo's time the technology had not been developed to raise the huge dome. The dome's design was an act of faith that the technology would emerge when it was needed. And, indeed, it did—from the hand of Filippo Brunelleschi.

In 1418 "Pippo" won the design competition and in 1423 was put in charge of the entire building's construction, including the dome for which he developed special construction techniques to raise the structure without a supporting framework. Among other innovations, he developed an ox- or horse-driven mechanism for hoisting loads of masonry. This **Hoist** incorporated a screw, gears, and weights—all of which would lift some 70 million pounds of brick, stone, marble, and mortar over more than a decade.

When completed, Brunelleschi's dome was a self-supporting, octagonal, double cupola of brick, which was laid in a herringbone pattern. It rose 91 meters (298 feet) high, and when the lantern was added to the top the structure attained a height of 114 meters (374 feet). Brunelleschi's dome became and remains a symbol not only of Florence but also of the Tuscany region of Italy.

Many other Renaissance artists developed technological innovations, both in the visual arts and in other areas. For example, Leonardo da Vinci (1452–1519) designed a wide variety of machines, from a **Multi Barrel Gun** (his equivalent of the modern machine gun, 1480–1482) to a **Flying Machine** (c. 1487). In the Northern Renaissance, Albrecht Dürer (1471–1528) in Nuremberg created a grid device, illustrated in his woodcut **Draughtsman Drawing a Recumbent Woman** (1525), in order to render proportion more accurately.

Another technological device served a function similar to Dürer's grid, the **Camera Obscura** (literally "darkened room"). A camera obscura, forerunner of the modern camera, is a box with a lens at the front and a screen onto which the image can be projected within the box. Scholars believe that Dutch artist Jan Vermeer (1632–1675) among others may have used a camera obscura to help him paint his accurate scenes of everyday life. A fifth-century B.C. Chinese philosopher first mentioned this type of device, and Leonardo described it in his notebooks. But the camera obscura did not come into wide use until the time of Vermeer and later. Vermeer's uncanny accuracy is evident in such works as **The Geographer** (1668), which shows in detail cartographic tools such as a globe, dividers, a square, and a cross-staff.

Leaping ahead to the late twentieth century, computer technology began transforming the making of art during the 1980s and 1990s. Artists today can use a computer to create plans for sculptures, ceramics, or other three-dimensional objects; to produce finished virtual works; and to render two-dimensional works. An artist can make a sketch, for example, and electronically scan it to create a computer file. Then, using a program such as Adobe Photoshop, the artist can manipulate the electronic image before taking it back to a paper printout to continue working by hand. Or the artist can choose to refine the image wholly within the computer program. In the latter case, the finished work may simply be a computer file that can be viewed onscreen, or it may be printed out for a more traditional, frameable work.

These types of computer applications have transformed the commercial art world in particular. For example, an illustrator preparing a book or magazine cover today may draft that image solely by using a computer. After submitting the image to an editor, suggested changes in textures, colors, or the placement of visual elements all can be effected electronically—without the old-fashioned necessity of re-creating a paper-and-paint piece. Such applications also are finding a place in the fine arts. Witness, appropriately, the online Museum of Computer Art (MOCA) at http://moca.virtual.museum. An example from the museum is Hungarian artist Istvan Horkay's (b. 1945) **Persian Gymnast I.** These kinds of applications reach beyond the art world too, into urban planning, cartography, architecture, and other forms of electronic imaging.

VISUAL THINKING QUESTIONS

1. When the huge dome of the Florence cathedral Santa Maria del Fiore was planned in the thirteenth century, no one knew how it could actually be built. The planners took a leap of faith that the technology would be there when it was needed. Can you cite other examples of long-term projects in which the technology needed to complete the project was not available when the project began?

2. Many technological ideas could not be realized when they were proposed, only to be created later. The camera obscura led to the modern camera. Leonardo's flying machine became the modern helicopter. Choose a modern technological device and trace its origins. What was the spark that set minds in motion to realize the new technology?

3. Many artists in earlier ages were scientists as well. Leonardo and Dürer studied anatomy and were engineers, for example. Today art and

science are more likely to be disconnected. Artists are artists, scientists are scientists. Why do you think this is? What benefits might be gained by crossing the gap that now divides these two sets of disciplines? Or are they better left apart?

SUGGESTED READING

King, Ross. (2000). *Brunelleschi's dome: How a Renaissance genius reinvented architecture*. New York: Penguin.

Krebs, Robert E. (2004). *Groundbreaking scientific experiments, inventions, and discoveries of the Middle Ages and the Renaissance*. Westport, CT: Greenwood.

Spalter, Anne Morgan. (1999). *The computer in the visual arts*. Boston: Addison-Wesley.

ONLINE IMAGES

Camera Obscura (various)
 www.brightbytes.com/cosite/portable.html

Dome (Brunelleschi)
 easyweb.easynet.co.uk/giorgio.vasari/brunell/pic4.htm

Draughtsman Drawing a Recumbent Woman (Dürer)
 www.kfki.hu/~arthp/index1.html

Flying Machine (Leonardo)
 www.kfki.hu/~arthp/index1.html

The Geographer (Vermeer)
 www.kfki.hu/~arthp/index1.html

Hoist (Brunelleschi)
 easyweb.easynet.co.uk/giorgio.vasari/brunell/pic8.htm

Multi Barrel Gun (Leonardo)
 http://gallery.euroweb.hu/html/l/leonardo/12engine/1milita4.html

Persian Gymnast I (Horkay)
 moca.virtual.museum/comments/horkay/horkay01.asp

Idea Guide

This guide is divided into three sections. The first is a **Subject Guide** to the chapters, arranged by broad subject categories: language arts, mathematics, sciences, social sciences, business and practical arts, physical education, and fine arts. The second section is a **Keyword Index** arranged by type of idea. A few specialized art forms also are included in the Keyword Index. Dominant art forms, such as painting, sculpture, and architecture, are not indexed because they are referenced in most chapters. The third section is an **Artist Name Index**. In all three sections, the number refers to the chapter in which the idea or artist is connected to one or more visual art forms.

SUBJECT GUIDE

Language Arts. A number of chapters contain ideas related to reading, writing, literature, and related subjects typically taught in the language arts. The chapters to look at are 1, 2, 4, 6, 8, 10, 11, and 13.

Mathematics. Chapters 8 and 12 specifically address ideas that teachers of mathematics can connect to through the visual arts.

Sciences. Chapters 8, 9, and 15 focus particularly on aspects of science.

Social Sciences. The arts connect well to various aspects of the social sciences, including religious studies, regional and multicultural studies, psychology, sociology, and other disciplines. Thus all chapters include some reference to the social studies. History is touched on in most chapters and is specifically the focus of Chapter 6.

Business and Practical Arts. This area of study includes subjects such as economics and technology. The chapters to look at are 2, 7, 8, 9, and 15.

Physical Education. Sports connected to the visual arts are featured in Chapters 3 and 4.

Fine Arts. The visual arts appear in all chapters, of course. But ideas also touch on theater and film, music, dance, and related forms of artistic expression. The chapters to look at for these aspects of the arts are 1, 2, 4, 5, 6, 7, 8, 9, 10, 12, 13, and 14.

KEYWORD INDEX BY CHAPTER

ARTIST NAME INDEX BY CHAPTER

CORWIN PRESS

The Corwin Press logo—a raven striding across an open book—represents the union of courage and learning. Corwin Press is committed to improving education for all learners by publishing books and other professional development resources for those serving the field of K–12 education. By providing practical, hands-on materials, Corwin Press continues to carry out the promise of its motto: **"Helping Educators Do Their Work Better."**